JIM DINE

PRINTS: 1970-1977

Published in Association with
the Williams College
Artist-in-Residence Program by

Icon Editions
HARPER & ROW, PUBLISHERS
New York, Hagerstown, San Francisco, London

JIM DINE PRINTS: 1970-1977.
Copyright © 1977 by the President and Trustees of
Williams College.
All rights reserved. Printed in the United States of America.
No part of this book may be used or reproduced in any manner
whatsoever without written permission except in the case of
brief quotations embodied in critical articles and reviews.
For information address Harper & Row, Publishers, Inc.,
10 East 53rd Street, New York, N.Y. 10022.
Published simultaneously in Canada by Fitzhenry &
Whiteside Limited, Toronto.

The cover illustration is a detail from *Pink Chinese Scissors*
(catalogue number 210).
The frontispiece is one of the series *Self Portraits (1971)*
(catalogue number 47).

Library of Congress Catalog Card Number: 77-3758
ISBN 0-06-430083-8

78 79 80 81 82 10 9 8 7 6 5 4 3 2 1

CONTENTS

Jim Dine
Prints: 1970-1977

Williams College Museum of Art
October 3-November 5, 1976
The Johnson Gallery of Middlebury College
January 5-January 30, 1977
University Art Gallery, State University of
New York at Albany
June 26-August 5, 1977
Herbert F. Johnson Museum of Art,
Cornell University
September 30-October 30, 1977

Williams College Artist-in-Residence
Advisory Committee

ACKNOWLEDGEMENTS

The exhibition and this catalogue were organized, designed, and produced through the collaborative effort of the staff of the Williams College Artist-in-Residence Program. At the heart of the effort, Tara Devereux undertook the painstaking task of obtaining and organizing documentation for some two hundred prints and writing the process descriptions for the catalogue raisonné, as well as organizing the mounting, framing, and installation of the exhibition. Catherine Evans was responsible for the biography, exhibition list, and bibliography in the catalogue and innumerable other tasks related to organizing and mounting the exhibition. But for their thoroughness, diligence, round-the-clock perseverance, and advice on all matters related to the writing, design, and editing of the catalogue, neither the exhibition, the A-R Program nor the catalogue would have come to fruition.

The catalogue and exhibition would not have been possible without the support and assistance of a number of friends and colleagues associated with Williams College, in particular, Stephen Lewis for his guidance in organizing the Artist-in-Residence program, Franklin Robinson, Director of the Williams College Museum of Art, for his assistance with the exhibition, Jonathan Aaron for reading and suggesting changes in the manuscript, and Whitney Stoddard, S. Lane Faison, H. Lee Hirsche, and Stephen Paine who were generous with their time, support, and encouragement during the entire project. Susan Lyons, Phillip Eagleburger, Ellen Berek, and Flora Roedel provided valuable assistance on specific aspects of either the catalogue or the exhibition.

We are indebted to Riva Castleman for contributing the critical essay on Dine's prints. Mark Livingston provided sound advice on the catalogue design. Mrs. Elton Burbank obtained documentation on the prints from Petersburg Press on a trip to London, saving us valuable time in the early stages of the catalogue preparation. Pace Editions, Inc. supported this endeavor right from the beginning and their promise of advance orders helped make a catalogue of this scope a reality. Susan Lorence of Petersburg Press in New York and Paul Cornwall-Jones and Kate Reggett of Petersburg Press, London, Donald Saff and Alan Eaker of Pyramid Arts, Ltd., and Tatyana Grosman, William Goldston and Tony Towle of Universal Limited Art Editions provided indispensable documentary information on all the Dine prints that their respective organizations published. Excelsior Printing Company made a special effort for us in the production of this catalogue. In particular, Leonard Smith immediately sensed what we were trying to do. He was always available with sound advice and guidance and his insistence on high standards helped us to realize our intentions. Walter Kasheta provided valuable assistance with layout and design.

The key figure in the whole endeavor, of course, was Jim Dine. He provided the prints, the time, the energy, and the patience. We hope this volume does credit to his work.

Thomas Krens
September 1976

CONVERSATIONS WITH JIM DINE

The following pages are from conversations I had with Jim Dine on a number of topics related to his life and work as an artist. We talked in New York City, in Putney, Vermont, and in Williamstown, Massachusetts in July and August 1976. The conversations were taped and the transcripts edited specifically for this catalogue to accompany a retrospective exhibition of Jim Dine prints at the Williams College Museum of Art. In the text, Dine's comments are set in Roman type face, and mine are in italic.

Thomas Krens
Williams College

I.

*How do you account for your recent figurative work? Given your very early
success as an avant-garde artist in the late fifties, your involvement with
happenings, and your subsequent career as a pop/personal artist—the maker of
tools and bathrobes—your latest drawings of nudes and figures seem a
dramatic and even an unexpected change. Except for occasional gestures that
seem to be remembrances of your own artistic past—small objects attached to
the drawings or the smudges and occasional offhand marks that were your
particular trademark—the work seems to represent the tradition of an older
century, with a concentration on the craft of draughtsmanship, the illusion of
space, and the emotional and the psychological content of the picture. At this point
you seem to be turning away from the kind of modernism in art of which you
were a forerunner in the late fifties and early sixties. How does this transition
take place? Why a sudden change to representational pictures? What were your
experiences with Allan Kaprow and the avant-garde in the late fifties and how
do they now affect your view of yourself as a maker of art in 1976?*

To begin with, in 1959, when I came to New York, Allan Kaprow particularly
impressed me—influenced me. Kaprow expounded a point of view of art as a
process of continuing change. If something was not new, if the artist was not
creating something totally new, Kaprow argued that the artist had sold out. For
example, Rauschenberg at that time, in 1959, was at the height of his powers as
an artist, and he *was* making something new. But Kaprow would say things
like, "Rauschenberg used to make such dirty things, full of dirt and schmutz
and things and now he's cleaned his art up because he's become famous, and
makes art for an audience eager to buy his work."

Kaprow was a complicated figure. For one thing, he exerted an influence greater
than his notoriety would seem to have indicated. He brought with him a lot of
students from Rutgers. Lucas Samaras and Robert Whitman were students of his
and he was good friends with George Segal. Kaprow exerted a strong influence
on all of us in New York at that time, particularly me, because I was the
youngest and probably the most impressionable. Oldenburg, after all, when I
met him, was thirty-one or thirty-two years old. He was formulated as an artist;
he could have gone a variety of ways. He's an awfully powerful artist, full of
ideas, and he used the situations that we were all in at that time as just another
canvas for him to do something with. But I was only twenty-two years old at
the time—a kid, just out of college. Kaprow was there—older, stronger, and an
intelligent man. He influenced me as a teacher influences a student. Kaprow
maintained that if art wasn't new, it wasn't worth it. One had to keep going

beyond, he said. Painting was dead; Jackson Pollock killed painting by dancing around the canvas and using rocks and other things from external sources—bits of glass and other things he could find—in his paintings. Kaprow wrote an article in *Art News* about that. It was called "The Legacy of Jackson Pollock," I think. The legacy was us. The legacy was visual events—dancing around the canvas and using junk—but without the canvas. Those were happenings. The whole idea of Jackson Pollock—I mean the idea of cutting himself off so totally from so-called easel painting—was what Kaprow stressed. Of course, as we know now, Pollock went right back to easel painting before he was killed.

Kaprow made us feel important, in a creative and revolutionary way. He made us feel like brave young soldiers. I mean that was the way we felt. We felt right out there in front, brave young soldiers being put up in the trenches, the first ones to go over the hill. And we felt like that all the time because of what was being said around us. Our egos were fed. *Time* magazine latched onto us and the whole thing was blown out of proportion, raised to incredible heights. You know, at that time there were lots and lots of guys around who had already paid their dues, guys who were working their asses off in their studios and were serious about art, thinking that painting wasn't dead. The media didn't come trooping down to Gandy Brodie's studio. Do you know of him? I think Gandy Brodie was a marvelous artist and he died unrecognized, just a total victim of all the 1960's hype.

And so something happened to me in 1961 because of all these things. I began to feel that I couldn't go on just making happenings, acting in skits, and pouring paint on myself. I wanted to do other things. I mean I wanted to make paintings. So, in a certain way, I defected. I went off on my own, had my own studio. It's not unlike right now, except that I had no maturity back at that point. I had felt that the whole scene was not quite right for me. Although I had been told that I was being swept along on this wave of avant-gardism, it seemed to me newness for the sake of newness. My success, or notoriety, made me nervous—I was very uncomfortable with it, for a variety of reasons. In the first place, I felt it was undeserved. It was the media saying, "Well, okay, you're the greatest artist this week, but next week we need someone else to be the greatest artist." That in itself wasn't bad, but I did feel guilty. There were those in New York that I knew who had worked like hell—who were talented artists, and here is this young schmuck who comes up and pours paint over himself and it's meant to be profound. I was just uncomfortable.

Also at that time I was having a personal breakdown and beginning my open-ended involvement with psychoanalysis, so that I wasn't able to appreciate what was happening to me in terms of fame and success. I was involved with myself, trying to keep myself together somehow. I kept on working privately. I was cut off from my peers by my own choice. I really had nothing else to say to them. I kept on working and pushing my images further, taking chances in terms of putting disparate elements together, and in terms of the content of the work.

Anyway, that's what happened. It's simplified, but it sort of is what happened.

I am still interested in the degree to which you were aware of, or felt influenced by, an historical awareness of the concept of the avant-garde. The fact is, your initial reputation, a reputation that I would guess has had a significant influence on your subsequent life and career as an artist, was made through your involvement with the avant-garde in 1959-1960. Also, a painting like Black Bathroom *(1962), with the bathroom sink attached to a white canvas drawn with bold black brush strokes, is a specific example of your motivation by avant-garde tendencies.*

First of all, it wasn't a question of me being aware or unaware of the concept of the avant-garde back then. Remember, I was just a kid. I had just come to New York from school at Ohio University, where I read *Art News* every month. I learned all about the avant-garde and abstract expressionism from the text of criticism written by poets like Frank O'Hara and John Ashbery who made a romantic and heroic thing out of a guy making a white line across a canvas. It influenced the hell out of me. Yet I'm quite an expressionist thinker. It comes naturally to me. So DeKooning's art was appealing to me, because it was involved with the draughtsmanship of the past, because it was far-reaching and farsighted, but also because he could really move paint around. I thought then, and I still think now, that it was very beautiful work. Those were the influences on me, and if I had been of that generation, that's the way I would have painted.

But when I did come to New York, I was aware of the fact that I was of another generation. Different things were happening then, and I got involved with them. What Kaprow was saying appealed to me so I went along. Happenings were not all that I wanted to do, but were what I was locked into by time and events. It was expected of an energetic young man with talent. Kaprow's idea was that these happenings, these events in time and space, would replace painting. At least that was my understanding. Maybe I was terribly naïve, but frankly I felt weakened by that, in the sense that I didn't want to be an actor, and that's what it seemed like I was. It was painters' theater. For me, it was very interesting: blackouts, vaudeville, burlesque, skits. But it was related to theater; I was a painter. The happenings threatened me. I was pushed by myself, by no one else, and trapped by myself into making happenings. So it wasn't a question of avant-garde or not avant-garde. I was attracted to Kaprow, participated, and when I found out it wasn't for me, I got out. But I couldn't leave my new reputation behind.

When I started to paint, I had some really terrific ideas. New ideas. I was doing exactly what I wanted to do. I went on my nerve. Like that sink, for example. I tried to follow a theme of interiors and talk about that in the paintings, and instead of painting the interior, I would set up an actual object in the interior. They were avant-garde only to the degree that my own ideas coincided with a definition of avant-garde at that time.

But when, and why, did you start making figurative art? As recently as 1973 you had two paintings in the Whitney Annual that seemed to me like

unsuccessful attempts of an avant-garde veteran to reassert himself. The paintings had the familiar Jim Dine hearts and abstract expressionist brush strokes right in the middle, the canvas had been taken off the stretchers, ropes led from the canvas to piles of stones in front of the paintings, and sticks were propped against them. The paintings tried to invoke an avant-garde newness —but the vocabulary had already become commonplace. Your next show at Sonnabend was in much the same vein—large abstract paintings decorated with tools, influenced by your successes of the early sixties. There was still no suggestion of the figurative work of 1975-1976 like the Blue Nude *and* Baby *drawings.*

That was a crucial time for me—crucial for my art. I felt after the show of paintings at the Sonnabend Gallery in 1973 that I just couldn't affix another object to a beautifully painted field, and ask the viewer and myself to get that metaphorical charge from it that was inherent and built into it. Because otherwise it would just be what it was (an abstract painting), and that wasn't enough. The tools made it a symbol for something else that I was not then articulate enough or brave enough to speak about directly. I felt that tools had become too much of a prop.

Also, I believe that all I was doing during the sixties and early seventies was to get where I am now. It's interesting that you should mention the paintings that I had in the Whitney show. (One thing, however, the canvas was stretched— just the edges weren't tacked down. They were ragged.) But those paintings are so much a part of what I am doing right now, I can't tell you. I made those paintings in the summer of 1971. I set up a tent in a field, with easels on the ground, and I painted outside all summer. I was influenced by my young cousin, Richard Cohen, who is a painter, not professionally—he's a carpenter—but he's a very good artist, a terrific artist, very much more schooled in the past than I am. He was doing some pretty weird things, but he was always drawing. He influenced me to get back to painting the way I could really paint best, and those Whitney things are testaments to painting, to easel painting. The paint is really moved around, and they are very free. I was coming more to the identification of being an artist in the traditional way. It's hard to explain and probably hard to visualize, but every night that summer we drew each other, my cousin and I, or my kids and I. It was the first time in a very long time that I got back to that kind of thing. We had walls of figure drawings of heads. They were rather casual, but I started to feel like an artist. Before, it sounds dumb, I know, but I didn't necessarily feel like one. I felt like a showman. I felt like I was a part of history, knowingly. I felt it was because I was on this treadmill of avant-gardism, this avant-garde factory.

I am not rejecting avant-garde art, nor am I ignoring its implications. I am only explaining what it was like to be really a child at it. I don't consider my involvement with the avant-garde invalid—only immature. Not necessarily in terms of my years, but in terms of what's needed and what's proper and what's relevant for me in this world. Anyway, the style of the avant-garde right now has become too popular—it's being imitated by everybody. Lawyers act like avant-garde artists. It has become too common an act and it has become too unnourishing.

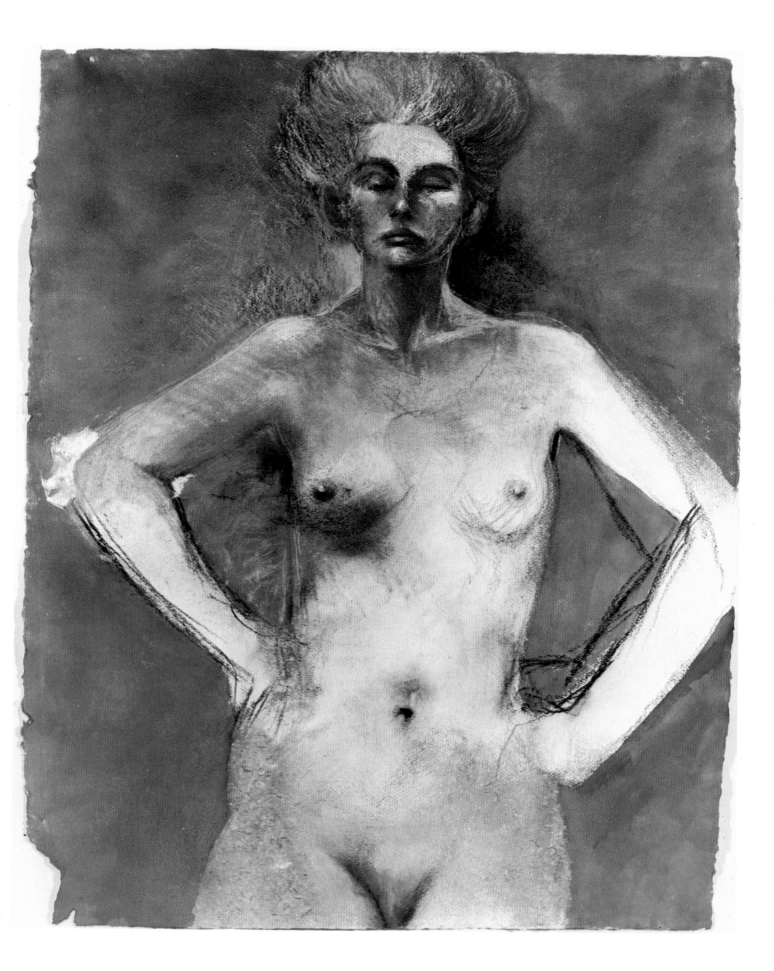

Blue Nude (drawing) 1976

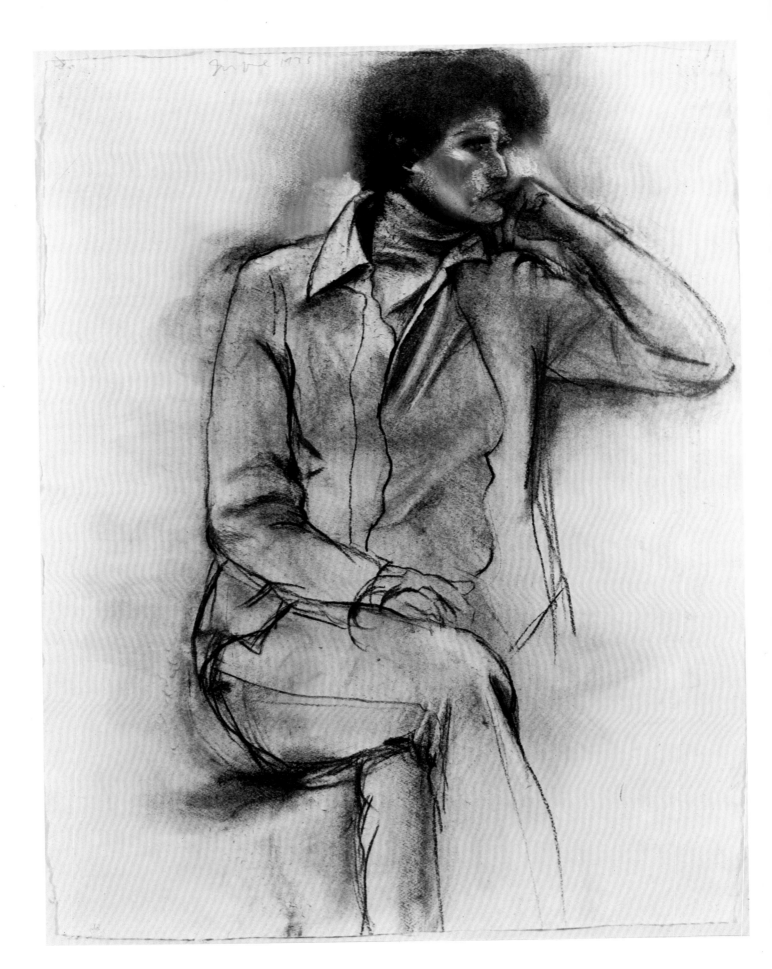

Russian Poetess (drawing) 1975

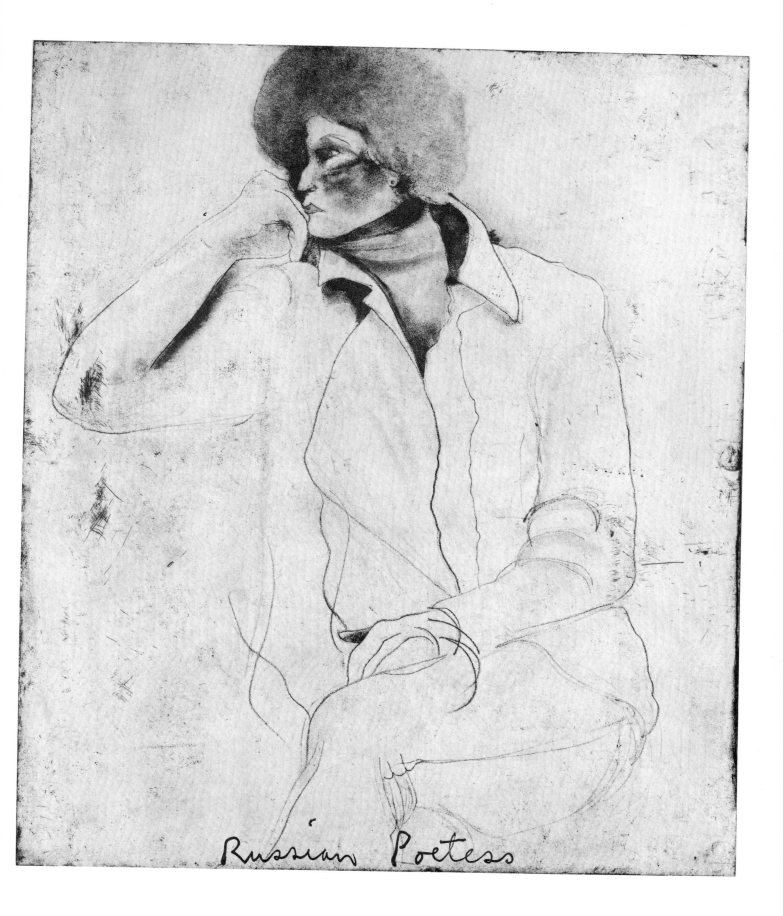

Russian Poetess (etching) 1976

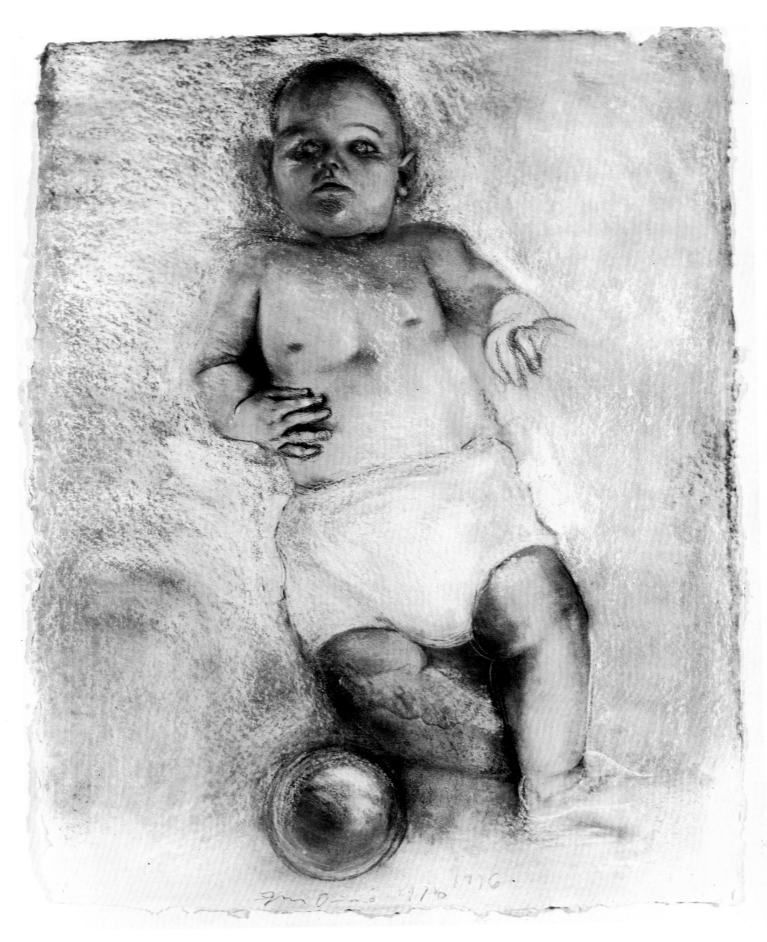

Baby (drawing) 1976

Going back to what you said before, it may have been something at the time when I first came to New York that I had to do—something that history dictated. After I gained notoriety, there was a great deal of pressure to maintain it, and I responded to the pressure that was around everybody. I'm not a recluse. I am aware of the urges and the things that are happening around me, all the little things that make up the big things, and that's exactly what I did—I responded. Since I was very young, psychologically young and emotionally immature, it gave me something to respond to. I didn't have anything that was just my own. I wasn't a very strong person then. I wasn't in tune with the powers that I have. I was less confident and unwilling to accept my insecurities. So I put up a façade. I responded. I heard the bell and came out with an idea. I heard another bell and came out with another idea. It was like that—ideas, ideas, ideas.

But the point that I objected to even then was that it was too self-conscious. It was prejudicial and intolerant to the extent that I excluded many things, other things in our culture, older art. It wasn't until I was into my thirties that I got back to looking at old art because I had been programmed to think that it was just a lot of garbage. I just read an article in a recent magazine—a profile of a leading contemporary artist—and in it he said how boring it was to go to the Metropolitan Museum of Art and look at all those old paintings. I can't think of anything I would rather do. It took a long time for me to go back to the Met and look at all that stuff. Kaprow gave me the idea that John Cage was the only composer. I stopped listening to music—that's how *stupid* I was. That's my stupidity, though, to have taken it all in.

I get the feeling from what you say, that finally after twenty years as an artist, you feel that you're getting stronger in your own personal conviction, that your better work is yet to be seen.

I think so. It's not a question of becoming stronger in my personal conviction. It's that I'm getting some personal private conviction rather than public. And that's the only thing I really care about. The only thing I care about is making art and doing art. In the first place I love doing it. It's a true pleasure. And if I can do it intelligently and turn out a painting or two that I'm pleased with, then I'm way ahead. I can't think of doing anything that has more dignity.

II.

Your art has always seemed to have a great deal to do with literature—especially poetry. For example, there's the much referred to use of objects in your work as sexual and psychological metaphor. Your work has always seemed intensely autobiographical and made liberal use of the associations of tools, clothes, and your personal environment. Then there is the involvement with poets in the production of a work, for example, a 1970 lithograph titled The World (for Anne Waldman), *a collaboration with Kenneth Koch on a 1966 silkscreen, a collaboration with Ron Padgett on a series of 1970 lithographs, and your planned collaboration with Robert Creeley. Finally, there is your use of lives of poets as narrative material in your work—I am thinking of the Rimbaud series and the works based on Flaubert. How important was this literary influence for you, how did it develop?*

As I said earlier, during the sixties in New York, I found I was having difficulty identifying with the work of other visual artists. I didn't find any true comrades among my peers in art. But I didn't seem to have that difficulty with some poets. Maybe because I'm a much more literary person. But I can't quite believe that. I did write some poetry in the late sixties and found that I wasn't a writer. The point is, I felt their minds were more subtle and more receptive to what I had to say, and they were more interesting to talk to and to relate to socially, not that they knew any more about art than anybody else.

In the early part of the sixties, I felt more and more isolated from what was going on around me in the art world. I reached a point in 1966 when I stopped working and didn't draw or paint until 1969. I did it because I felt completely alone and out in the cold in relationship to the New York art scene. I moved to London to look for another place I could paint about, relate to, or feel comfortable in. Also it was cheap. I was nearly broke at the time and you wouldn't believe how cheap it was to live in London then. The poets that I corresponded with were so generous in sharing their ideas with me, without a thought as to whether or not they were going to lose anything by it, and their confidence in me as a person who understood what it was like to make art—all those were very pleasant associations for me. I am talking now about Creeley and Ron Padgett, and Ted Berrigan and Kenneth Koch, and Ashbery. These people were very different artists in their own ways, but they all dealt with me in the same way, that is, they had no questions in their minds that I was an important artist; by artist I mean poet, musician, painter, whatever. They related to me that way and I never felt that I had been treated that way by my peers in the art-making world in New York. So it's natural that I was attracted to them. I collaborated with them because one gets lonesome being an artist by oneself. I still retain some contact with those poets—but by mail mainly. I am about to produce a book with Robert Creeley—a book of etchings and a prose piece. I would like to do something with John Ashbery, who I think is a wonderful writer.

My relationship with poets and with literature has been important for me

artistically in the sense that it has allowed me to compare what it is to make art with great art. It has given me an opportunity to see that other people have had experiences similar to mine, that I could relate anxieties and things to literary figures and see that I wasn't alone in the difficulties of moving into adulthood or the vast stream of life. It was easier for me to identify with literary figures than with painters, to define for myself the fabric of life.

How much were you influenced by actual literature? Take Rimbaud, for example, was it his poetry or the dramatic story of his life that provided you with initial inspiration?

Actually, it was neither. I was impressed by Rimbaud first as a still life. The Rimbaud series began several years ago when I found a French popular history magazine in a bookstall on the quai in Paris. The cover of the magazine had a portrait of Rimbaud, probably by some nineteenth century academician, and I was attracted by the way the face looked, physically. Seeing his face in a bookstall on the Seine—it just struck me how interested I was, how much he looked like a young boy, how amazing his face was. I then read his poems, and about his life, and that really fascinated me, but it was his face that I was attracted to.

What about the contemporary poets that we have talked about? Were you influenced by their work or their lives?

I wasn't influenced directly by their work. I respected them as artists but I was influenced mainly by their friendship, their very generous friendship. I'm not sure that I understood what they wrote about all the time, or any of the time for that matter. I became friends with these people and our friendship was based on a mutual respect we felt for each other as artists, and I identified with their attitudes towards art. I didn't find any comrades in the visual arts. In the early sixties, partly because of all the attention I was receiving and partly because of my inability to deal with the artistic and social pressure, I felt all alone. I felt I was in the wrong country. I didn't find a *true comrade* in painting until I moved to London and met R. B. Kitaj. He's an American, but he's an Anglo-American. Not until I met Kitaj was I able to speak to someone who I felt understood what I was talking about. And vice versa. I find that you do need some external validation for your art and life, and I found this validation with Kitaj. I mean my art life, not necessarily my paintings specifically (we do paint quite differently) but we feel similarly about art on a larger scale.

Kitaj's cranky. He's tremendously bright, very stubborn, very pissed off, and very nice in that way. I know his work better than most people because I love him, but also because he has been in many ways a peer-teacher to me. His work, like Balthus', is one theme played over and over in different variations, but

getting stronger and clearer all the time. At first I didn't understand it, thinking it was so muddled and imprecise. But after a while I came to understand it and found that it was very precise. It really is the equivalent of some kind of historical statement for the first half of the century, and I think that that's an incredible accomplishment. When he is through, I think that he will have a body of work that is going to be dazzling as a depiction of human beings in this century without any bullshit. What he aspires for are things that I never thought I was capable of.

What about contemporary art? What do you think of contemporary realist painting?

Some of it is interesting, but most of the modern looking stuff is just awful. I think of someone like Chuck Close as a great weightlifter. I am astounded by his work. He made a mezzotint that's one of the great triumphs of technique. But he had to leave those little squares in it—that whiff of modern formalism. He had to do it, because it's chic—but let's face it—it gives the print the stamp of conceptualism—of phoney engineering.

But besides Kitaj, I have to keep coming back to Balthus because every time I see one of his paintings, I am moved in a different way. I have this feeling that Balthus paints what he sees—that he confronts his subject matter personally and paints from his own experience. What inspires me about Balthus is the cool sexiness of his work. I understand that obsession, not necessarily do I have it, but I understand it. And I like the very peculiar bent way it's rendered—a kind of Cézanne way of drawing. He makes a kind of timeless, eccentric art, which seems to me, in these eccentric times, far better than most things done.

Balthus' paintings strike me as particularly personal and particularly European. For one thing, there's a remarkable stylistic consistency about his work that has been maintained for almost fifty years. He has taken a stance outside formal and aesthetic developments in art of the last half century and has remained rigidly individual and rigidly independent. That in itself is no mean feat. It must take great presence of mind. As I recall, he puts out very little biographical information about himself. Instead, you get it from the paintings. Through his paintings you get a definition of the man, his character, interests, philosophies, and obsessions. He's very enigmatic, sphinx-like, full of personal and poetic meanings. The sex in many of his paintings provokes but never consummates.

Are you intimating that you aspire to develop characteristics like these in your own work?

Not necessarily. All I am saying is that Balthus inspires me. (Actually, I saw some Balthus drawings with Kitaj in Europe, and they specifically inspired me to begin the drawings I'm working on now. His drawings weren't all that great. I'm positive mine are going to be better. I have a competitive spirit.) But I don't aspire to be like him. As I just said, he paints what he sees. He doesn't have to take a figure apart and put it together in a weird way to get his point across, to express his very particular vision. He is not a man who is frightened to put into a picture exactly what is there. Because of what he is, he doesn't have to distort for reasons of distortion. We are so lucky to have amongst us a man with that kind of vision, and the ability to make it over into incredible pictures. What appeals to me most is the single-mindedness. It's impressive. He's a man to be reckoned with, a man to be revered and learned from. His is a kind of impeccable art life. He's not been fucked around by the jungle of the cities and he hasn't played the games. He does what he wants to do. He charges his paintings with his quirky way of seeing—and I'm not thinking just of the explicit sexual paintings—but the paintings of Derain in his studio and the one of Miró and his daughter. He's quite simply a remarkable artist. He acts like an artist.

Critics have frequently mentioned Balthus' connection with Courbet as a source of inspiration, particularly in reference to his treatment of children—the detached, self-absorbed insouciance that characterizes Balthus' children. I think the predecessor in this case is Courbet's painting of Proudhon and his family. Your new figurative, realistic work seems so strange, so unusual, especially when compared to your work up to 1974, that I have to ask the obvious historical question, are there any direct inspirations, perhaps from Balthus, for your new work, especially for things like your series of baby drawings?

Oh no, that's just his obsession with young girls. My obsession is not with children, necessarily. I'm just happy to be making pictures of babies. In an historical way, I like Vincent van Gogh's drawings and paintings of babies and children, not Balthus'.

But I do compare. I mean every day when I make a work of art, I open a book and compare it to a great work of art from the past. It seems to me like a reasonable thing to do. Artists have always done that—looked at other art. I look at my art books. I compare what I've done to the past because where else do I come from?

But that's new. You haven't always done that.

Oh sure, I have. It's just that I distorted it along the way to fit my means.

How do you know you're not distorting it now?

I'm quite sure. It's procrustean.

What if someone had confronted you with that ten years ago? Would you have said the same thing?

No, I wouldn't have been so sure. But then ten years ago, I didn't know as much as I know now. And I don't mean that in a smug way, because I don't necessarily know very much. But I do know something about myself that I didn't know ten years ago: I'm convinced that I have to do this now. I have no idea if it's good. I really don't. I like it, I like what I'm doing, but I've always liked what I've done at that particular moment. I feel now more serious about what I do than I did before and not serious in some academic way, I feel serious because I've put my finger on the seriousness of what I do, of what I intend to do. And that is to be an artist, and act like an artist.

Another person who acts like an artist is Francis Bacon. I don't particularly relate to Bacon's work, but I do think he's an effective artist for what he has done. Right from the beginning he has followed his own interests, independent of all the activity going on around him. I would say that he has behaved personally and he has behaved properly as an artist. I am not interested in the distortions he makes of the figure, nor do I understand the particular way he has of handling paint, but I am in tremendous admiration of him, because he is ambitious in art and because he paints on a grand scale. I think it's great to be ambitious like that.

Someone else whom I admire very much and have never spoken about before is Joseph Beuys. I have never pretended to understand him, but I have been moved by his stance towards art, by his life with art, and by his draughtsmanship. Beuys once sent me a message via someone else, saying that of all the paintings he had seen in a private collection in Switzerland, the only painting he liked was mine. At that point I knew very little about his work, but in the last couple of years I have been confronted by it more and more, mainly in drawing shows. I've found his work super-moving and very beautiful. I was looking at the catalogue you had on your desk last week of the Beuys show, I think it was called *A Secret Block for a Secret Person in Ireland*. They are really terrific. Those early drawings from the 40's are just superb, like Chinese paintings. In those drawings you can see what a great artist he is. They are very moving. They are charged with romance about what he is doing.

But Beuys is not just a draughtsman. In fact, most of his visible latest work seems to be based on a kind of personal/political interaction with the viewer/gallery goer or on his role as a teacher of art or on performances that seem very close, in form at least, to happenings that you were doing in 1959. In 1974, for example, Beuys had an exhibition in the United States at the René Block Gallery in New York . For that exhibition, a large metal fence transformed part of the gallery into a large cage. In it, Beuys spent three days

with a coyote, some straw, a flashlight, a cane, and a large blanket of felt.

That's not what interests me about him, though. What does interest me about him is the fact that he is a highly original person. And he has made himself a highly original life. He has integrated his art with his life in an external way—in the sense that he has invited people inside to take a look at his life. That can be interesting but it also can be boring in the wrong hands. For Beuys, it's interesting because his art and his life seem to be the same thing. They seem to look alike. They seem to have the same fabric. I don't know that I could take any of the performances literally. I can't suggest what the event you just described would mean. But I know in my toes that it's charged with something highly original from a very powerful human being, and that interests me.

There's no question that Beuys has great balance, that he is able to move in several ways or in many mediums, retaining his elusiveness, resisting a specific definition and classification, even explanation, yet at the same time maintaining great conviction, making a kind of art that is seductive and convincing. There are elements of the sphinx again.

Beuys' art speaks clearly, even though it is not distinct or literal. He has an ability to express an idea from one point of view that is multifaceted and an idea that is conveyed by his art with great power. He gets through because it's a very powerful original gift he has. Plus he really draws beautifully. That never hurt a great artist.

III.

My attitude towards drawing right now is a more elaborate attitude than I had earlier in my career. I am not as easily satisfied now as I was then. I need more of a full blown drawing for myself now. My attitude towards drawing is not necessarily about drawing. It's about making the best kind of image I can make, it's about talking as clearly as I can. I am much more comfortable making these very elaborate, rich drawings and prints than I am with painting.

There has always been a very strong graphic quality in all of your work in the sense that a line, a mark, a gesture on a field makes a high contrast, figure-ground relationship that is classically graphic. In your earlier work marks were definitional or expressive. They were applied, in part, for their intrinsic value and tended to explain and define only themselves. I'm thinking of the smudges, brush strokes, crayon marks, and blobs of ink that were part of your vocabulary of the time and appeared so frequently in your drawings, prints, and paintings. An early print like Pliers *(1962) characterized this attitude. There is enough information to barely define the subject matter—a pair of pliers—but the marks are also spare enough and gestural enough to have a character of their own and to appeal to an abstract expressionist aesthetic. A drawing of a robe on canvas done in silver point emphasizes the ability of the robe to be rendered so simply, and also the ability of the line to be elegant in itself. By contrast, in recent drawings like the baby series and the nude series, that graphic quality has been replaced by a richness and elaboration that puts almost all the primary emphasis of the work on the subject. The technique does not isolate expressive marks and draw attention to the gesture. Marks build upon marks to construct a spatial illusion.*

Your latest prints, however, and I am thinking particularly of the Eight Sheets From an Undefined Novel, *seem to function in both areas equally well. They are rich, elaborate prints that have as their first emphasis the subject that you have chosen. At the same time they are quintessential prints, with all the graphic quality that has been the traditional strength of the printmaking mediums. I must confess to being seduced by the technique in the* Eight Sheets. *In many of your earlier prints I get the impression that the medium was like a new toy, and you were continually collaborating with printers on new experiments. But in the* Eight Sheets, *you retain an extraordinary touch and control over a medium that can easily lead to technical excess.*

That may be because those are the first prints that I did at home with my own press, and I had the time to keep on proofing. On almost all the earlier prints I was experimenting and learning, it's true, but I was working under very difficult conditions. I would do them in Europe, work on them for a few days, return a couple of months later, and work some more. It was an offhand way of working that was never very satisfying. It was all based on finding the right printer, but it really just meant that sometimes you would lose contact with the work and if the printer couldn't pull it out, then it wasn't a successful print.

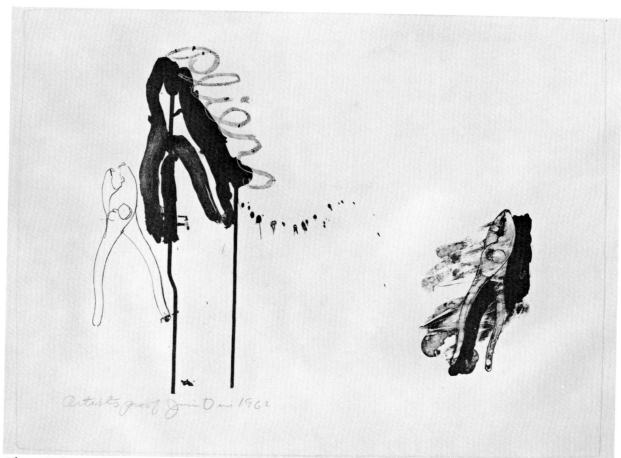

Pliers (lithograph) 1962

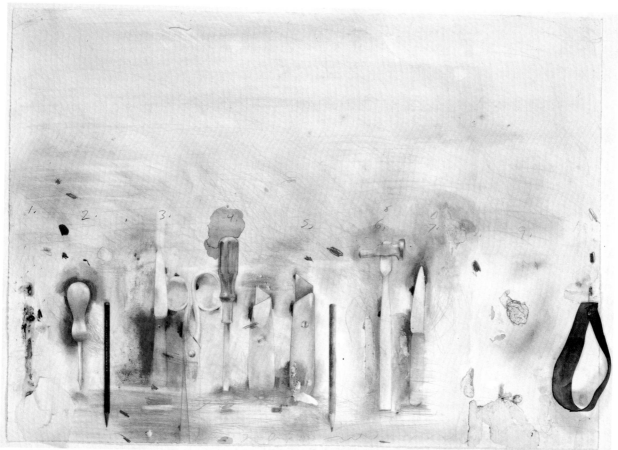

Tools (drawing) 1976

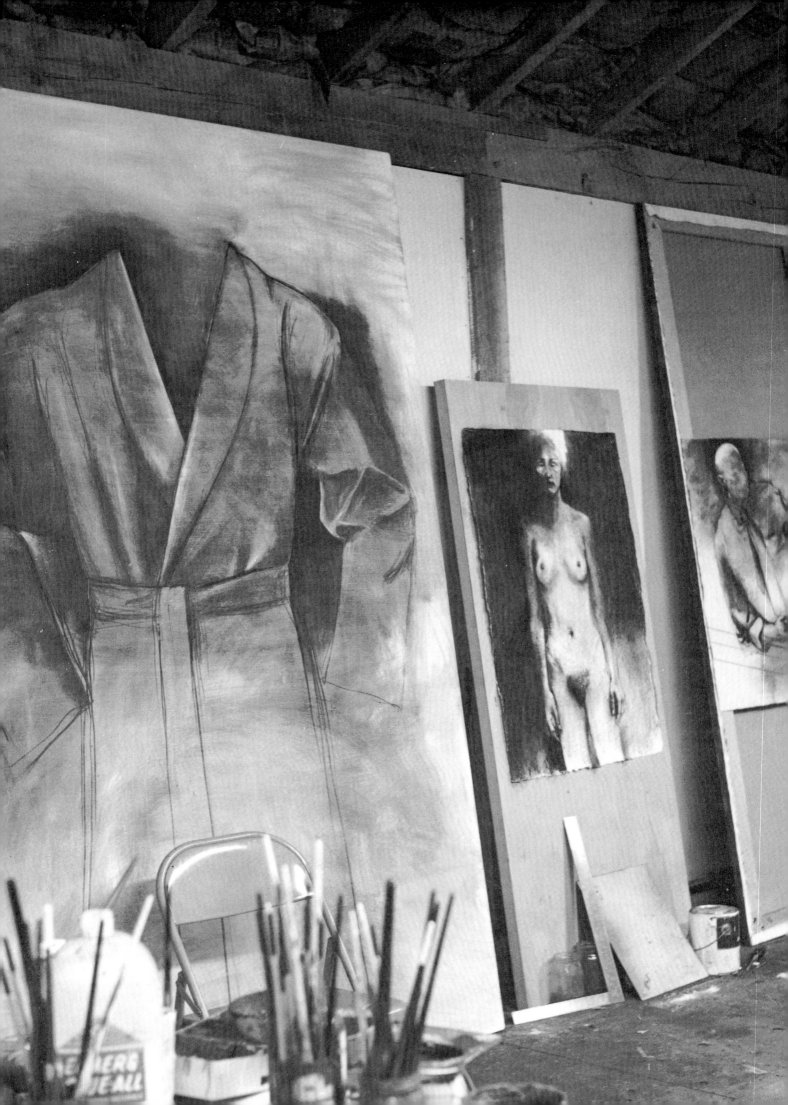

Working in one place for a long time on prints has taught me a lot. That traveling around was because of the insecurities of both the artist and the publisher about the act of printmaking, as if infusing it with some kind of jet-set life would make the work better.

The *Eight Sheets From an Undefined Novel* were all based on lengthy and elaborate preparatory drawings. The undefined novel defines itself, or it can be practically anything that you want it to be. I took a group of drawings I had been working on and decided to put them together in a series of prints. It also gave me the chance to use some words that I liked. Someone once told me about a Sufi baker, which seems like a strange combination of things—a Sufi and a baker. So I just used that word. It was like a free association. *A Nurse* or *The Cellist* or *The Swimmer,* I think all of those are nice titles for things, and they would be nice characters in an undefined novel because there is nothing specific about it. It seems that they could all go together.

The *Russian Poetess* was actually inspired by a photograph of a head. The drawing was changed a lot as I reworked it many times. The woman, Akhmatova, was a Russian poetess, a friend of Mayakovsky's, I think. I just liked her face. She had a tremendous hooked nose which I liked very much.

Once I had the drawings finished I wanted to get the same proportions on a smaller scale for the prints. So I had all the drawings photographed and 24 × 20 inch enlargements made from all the negatives. Then I traced the photographs, not elaborately, just a linear tracing, and put a soft pencil tracing down on a soft ground copper plate. After the soft ground outline was on the plate I went to work on the plates one at a time through many states. I think some of the pages had as many as fourteen states. I worked with soft ground, etching tools, and a great deal of reworking and erasing on each plate directly. I erased with a die grinder's tool and then burnished with steel wool and then reworked those areas of the plate with more soft ground. They were bitten in the acid very carefully, not deeply at all. I used roofer's copper instead of polished engraving plates. Roofer's copper is used in the construction industry so the plates are unprotected; they are scratched and marked, and instead of beginning with a blank surface, you begin with a totally full surface. And you add to that— drawing and erasing and drawing and erasing and rubbing out and wiping out— drawing and leaving your tracks and then going back. It's also a way to metamorphose things. I came to using soft ground in this series just by accident. I didn't know what I would get. I thought I would start with a soft ground and then go over it with hard ground, which I did slightly; it's touched up in places with hard ground, drypoint, and aquatint and the grinding tool I use to simulate aquatint. But they're essentially soft ground prints which are like drawings. They're more like drawings than most prints are except they could only have been done through printing. They're very intimate. It gave me a whole other way of speaking. I love them. They don't look as good as they did before they were steel faced. But because I used all those soft ground techniques, they had to be steel faced to get an edition of thirty out of them. The proofs, before they were hand colored or had the names stamped into them, were much warmer and much richer prints. I have states of those.

Why do you work from photographs or from elaborate preparatory drawings?

Jim Dine's Studio in Putney, Vermont

In the first place, I am not after the offhand, immediate quality that was so popular in the sixties. For too long I have wanted to get across the idea that I think anything is possible, that I don't give a damn who does what or what I do, that whatever happens offhand is for the best. Well that's all changed. Now I want to control what I am doing and if photographs help me make better prints, then so be it.

Secondly, and this relates to what I just said, I am inspired by the live model, and it is very difficult to see the copper and see the mark that I am making through the ground as clearly as I can on a white piece of paper. So for some prints, I would rather do the basic work on a piece of paper—it's easier and better. Then I reduce it to print size, transfer it, and work on it in a printmaker's way, using the copper, my hand, the cumbersome tools, and the acid without having to look at the model. I find this a much more effective way for me to make prints.

There is also a very basic difference between drawings and prints. One you do on paper and the other on copper with acid before it is printed on the paper. I don't feel precise enough in my abilities as a printmaker to work directly on the copper at every stage. I read that Mary Cassatt drew her drypoints directly on the plate, but she was also working with a kind of copper that was much easier to use. It had no grain compared to the grained, cold-rolled metal that is available today, and her copper was much softer, therefore much more receptive to the subtleties of the drypoint needle. I can't control or erase as easily so I like to get down the basic plastic reality of the figure before I commit myself to the copper. Once the drawing is on the plate, though, I certainly put it through enough stages.

Prints also look different than drawings. Look at the drawing and the print of the *Russian Poetess*. It's another way to get into something, the prints have qualities that are totally unique. I love to make prints. I have made them all my life. I like the medium. It's not that I necessarily want a more democratic art for all people, it's just that I like printmaking.

Making prints is as important to me now as making drawings or paintings. As a matter of fact, it was the only medium, in which, up until just recently, I felt free enough to be figurative when the pressure was still on to make those field paintings with the tools hung on them. Probably because the process was one step removed from me (with the printer in between), I felt that I could start to do that. I'm not sure exactly why I did it, but making prints was the first place my interest in figurative art raised its head.

Are time and experience—having twenty years to learn to be a good draughtsman, for example—making you a better artist?

Absolutely. Bacon said that painting is an old man's art, and I've found that that's true. What he means is that you gain in technical powers and in the control you

need to make the image you want to make. It sounds like the dumbest, most old-fashioned, puerile idea, but it's absolutely true. With the show that I had at Sonnabend of the tool drawings, I felt for the first time I could control my hand and make it give me the image that I really wanted. That show was a true turning point for my work. It began simply out of an urge to draw—to draw and not rely on anything but my ability to communicate through my drawing. And you are absolutely right. It has taken me twenty years to learn how to draw.

IV.

Right at the moment, considering your accomplishments as an artist and all that you know about art, what is the most important concern for you as an art-maker?

Subject matter. And for me at this point in time, the depiction of the human face is at the top of the hierarchy of subject matter—because it is the depiction of ourselves. All the other things, my hanging tools on paintings or using tools as surrogates for human activity, no longer interest me. Rothko once said that he would rather look at a painting of a bullfight than a painting of apples. I know what he means. Human activity is charged, charged with subject matter, charged with connotations, with so much more than just a wrench and a nutcracker, no matter what the setting. Really. If you are going to make a picture of people fucking, let's make it. You get to that point.

I suspect that when people see my recent figurative work I'll be called a revisionist—a turncoat. That's okay. I'm going where my passions lie. I asked a friend of mine what she thought of my new etchings, *Eight Sheets From an Undefined Novel.* She said that they are old-fashioned. That was so naïve of her to say. Are they old-fashioned because in the nineteenth century people drew the figure and now we eat the figure—literally—or we cut up the figure—literally— or we deny its existence? What is that bullshit, the pompousness of that attitude? All I want, all I want is to be alone somewhere and to give time to my art that I have not been able to give in the past because so much time was given over to maintaining my image.

Doesn't that deny a modernist attitude toward art-making? What do you think of the "idea-fication" of art, the ascendency of the concept of the idea over the object, art where the object does not have to be realized if the idea can be expressed?

It's kind of an anti-materialist stance. I think it's just fine. But I am unable to control myself. I have to make an object. I think that the other represents a very pure and admirable stance, and done by someone who is extremely intelligent, it has great style. But I am not interested in it because I *am* interested in making objects. I find great physical joy in making objects. My place is with a pencil in my hand.

Sure, I look at contemporary conceptual and video art because I would be stupid not to. It exists in the world with me, but it doesn't interest me and I am not very moved by it. Frankly, it bores me. I think that it's really ugly.

But you are being concerned with only its visual or visceral—its immediate

appeal, what it looks like. Aren't you denying other aspects that might be hidden in the work?

I just never saw anything that I thought looked good. What else can I judge it on but what I see? Just because it may have taken a long time to make and it works with ten laser beams means nothing to me. It's what I have to look at that makes the difference. I find it very unpleasant looking and not particularly interesting. (Although I thought that something like Rauschenberg's mud piece done for the *Art and Technology* exhibit in Los Angeles was just terrific.)

But it doesn't appeal to me in general perhaps because I am someone who has very little interest in science or math. I *am* very interested in nature, but not necessarily in science. If people never went to the moon, it would never mean anything to me one way or the other. Really, I am put here for one reason and that is to paint and draw.

You say that personally, but do you ever think that you might be outdated?

You mean some relic from the past, some throwback? If I thought that, I don't know if I could live with it. No. I think there will always be people who will want to paint and draw and I am one of them. I am a painter and a draughtsman. I have always been firstly concerned with ideas and how well I execute them. The situation now is different only in that I trust my ideas and my abilities enough to no longer have to worry about them. I no longer have to be self-conscious about asking myself, "Is it a new idea?" I'm not concerned about that because I know now that I have experienced something which I have never experienced before. I know what invention really means. I can invent without having to think about it. I can invent graphically, plastically.

Something appears on a page, not because I consciously want it to appear, but because I've got a storehouse of ideas, knowledge, feelings, all kinds of things, and therefore it appears for that reason. It's coming out of twenty years of unconscious absorption of the culture and personal trauma—of what I want to do and say about my relationship to the culture and how I live within it. I'm not negating ideas, nor am I negating what I did before. I'm merely saying that now, this is just another step in my development of me. It's the best thing in the world. It's the greatest thing that's ever happened to me—when I can now say to myself, I can feel it, and at an immediate time say, I am real. I am there, I am real. This literal mark I make is made by me, it's real. I don't have to worry anymore about that other stuff.

Look. I have great confidence in my drawing—in my ability to erase and return something better even if I did something good. I often just keep on drawing on the drawing. I've gained confidence, I didn't always have it. I was always eager to turn out a whole bunch of things. I was very glib with my line. I could do

toothbrushes. I could knock them out. There was a kind of excitement. Now the excitement for me comes in working over a thing and in continuing to work on it because I'm positive that when it really does work, when the drawing is finished, that something profound will happen if I have something profound to say, in the sense that I'm allowing all of myself to come out in the drawings.

As far as my conversion to representational painting is concerned, that is not the issue. I don't want to paint like Bouguereau. I don't think that he is a very great artist, while I do think that van Gogh and Cézanne are. All I am saying, is that subject matter is what I want to draw and paint. I want to draw people. I want to paint the human face. I want to paint objects that relate to me, that are personal, that people can recognize. I want to be able to *depict* the human face, charging it with all the things that I can bring to it with forty years of experience. I want to work on that. I want to devote a long time to that.

That's the way I feel now anyway because I've found nothing to paint about as necessary as that. So avant-garde or no avant-garde, I couldn't give a shit. It doesn't make any difference to me. I'm interested only in going where my strongest urges direct me, and that feeling is best expressed in the prints like *Eight Sheets From an Undefined Novel* and in drawings like the nudes and baby drawings that I am working on right now. For me those drawings represent the purest way to speak. It's also the simplest way not to lie. It doesn't require the build up, let's say, that painting does. I approach my prints like drawings. I feel most comfortable drawing with that tool in my hand, making that mark. And I'm just getting a little knowledge about it to just now start to learn a little bit about it, so that I can speak plainer, clearer. Frankly, I'm more attracted at this point in my life to the best that I can get from the graphic mediums, rather than the painterly ones. Because I have denied painting in oil paint so long that it's going to take me a long time to know how to paint. To be able to speak as clearly as I can through etching or through drawing. I can't speak as clearly through oil paint. My new oil paintings are of a more simple nature and that is harking back to an older image, the robe, although I've strengthened it a lot with the drawing. I'm preparing to paint more like I draw and print. But I'm preparing for it; I'm not ready yet.

JIM DINE'S PRINTS

by Riva Castleman

The major retrospective exhibition of Jim Dine's work held at the Whitney Museum of American Art in 1970 had little in it to contradict the artist's statement in its catalogue, "I'm concerned with *interiors* when I use objects, I see them as a vocabulary of feelings." In 1975 he stated for an exhibition of his work in Bordeaux, "I used them [objects] as metaphors and receptacles for my marginal thoughts and ideas." The second sentence appears to reflect, both in its past tense and tangential relationship to what had seemed to be the central issue of his work, the changes that have recently taken place in Dine's art.

Dine's prints have most often consisted of solitary or analagous images that initiate his personal metaphorical dialogue with the viewer. Each symbol has been treated singly or in diagrammatic groups. Monumental drypoint neck-ties in the early 1960s and lithographic bathrobes of the mid and late 60s have been stand-ins for Dine himself. Single palettes, filled with references to flesh, night, landscape and commercial paint, also represented the artist. The tools and personal machines (zippers, watches) that many considered Dine's link to Pop Art, were, in fact, the most intimate elements in his language. When combined with hair (in the zipper, on the brushes) they form one category of sexual reference. Erect wire cutters and awls hardly require identification as male sex symbols. The heart, ubiquitous object in his work of the late 1960s, has been Dine's image for his wife: in sculpture it was covered with stiff hair-like straw; in etching it has appeared as stylized pubic hair.

Most of Dine's prints of the past eight years were published by Petersburg Press in London where Dine lived from 1967 to 1971. During those years his printed production was prolific and varied. In 1969 he produced his *Cincinnati* prints, listing all the people he could remember in his hometown. He catalogued vegetables in his prints by grouping seed-packet representations of tomatoes, beets, turnips, etc. into rows punctuated by drawings of similar items. He arranged varied aspects of nature like so many patterns of kitchen wallpaper into a five panel screen. Hearts, tools, and shoes were also ranked into rows during this period which could easily be interpreted as the artist's reaction to conceptual art and/or concrete poetry (both arts of organization) or as his summation of past associations at a moment of redefinition.

Dine's prints record the challenge of his 1970 retrospective exhibition (though they were not included in it) in the creation of his *Cincinnati* and *Picabia* lithographs. Both are torrential outpourings of expressionist temperament. Although each of Dine's object metaphors had been portrayed with suggestive sensuality, not since his tortured *Car Crash* lithographs of 1960, records of a terrifying Happening, did Dine so openly present his personal emotional reality. Dine's prints of the last five years parallel, to some extent, American

society's near panic search for self-awareness. In 1971 Dine began to portray himself, his face nearly all beard and not too different in appearance from the large paint brush that was his alter-ego.

Dine's literary choices had already betrayed his romantic tendencies (he illustrated Oscar Wilde's *Picture of Dorian Gray* in 1968 and portrayed Flaubert in 1972). In 1973 he etched a series of portraits of Rimbaud, the symbolist poet whose short life had inspired the Surrealist writers and painters, spiritual godfathers to the American abstract expressionists. Metamorphosis, a subject of these authors, became a major element in Dine's prints. First and second states of his etchings had not been uncommon up to that time, but normally they consisted of changing the color of ink or reducing the size of the plate. A different sort of transformation began to take place in his self portraits: objects eventually obliterated his face (*Self Portrait in a Ski Hat*, 1974) or his face became that of his wife (*Self Portrait in a Flat Cap*, 1974). In the Fall of 1974 the first etched portraits with beard of 1971 were entirely altered by scraping and aquatint, revealing the now beardless artist (*Dartmouth Portraits*). The subsequent portraits, whether of Dine or others, have the haunted look of castaways.

In no other art form is the discussion of medium more prevalent than in printmaking. This is partly because of the diversity of the materials and means needed to execute prints, but also because there are artists who work in quite spectacular and unexpected ways with the print media. Dine is one of the few artists who moves from one medium to another with considerable understanding of what each will provide for him. The intaglio techniques (drypoint, engraving, etching) provide Dine with certain qualities of line and texture that result from the immutable precision of cutting into the plate or varnish covering (ground) to the vagaries of acid etching through the ground or freely on the plate. Lithography has, for Dine, been the medium that offered him size and color.

Unlike most of the painters of the early 1960's, Dine was not exclusively committed to one print medium. Although most American artists worked in lithography in the 1960's, many of them had their first printmaking experience creating etchings commissioned from them by Arturo Schwarz for his series of books *The International Avant-Garde* (1964). Claes Oldenburg, Robert Indiana, Roy Lichtenstein, and Andy Warhol were among the artists whose etchings appeared in this series, but only Dine continued to work regularly in that medium. Following the history of one image in Dine's printed work, the bathrobe, a relatively complete view of his approach to etching and lithography can be ascertained. The prints *Self Portrait (Zinc and Acid)* and *Bathrobe* which he did in 1964, the latter destined to be published by Rosa Esman's Tanglewood Press in the portfolio *New York 10*, were relatively simple line etchings. Both had large areas of scratched and scrawled texture, seemingly uncontrolled and gestural in the background of the former print, while more descriptive and patterned in the robe of the latter. He returned to the etched robe in 1972 with a single print made up of three bathrobes, each in one of the primary colors and treated in a different etching technique, but all with

identical outlines. Only a short while ago Dine completed *Red Etching Robe* in which a soft red robe emerges from a sulphuric darkness. Technically more complex, the 1976 print incorporates not only a variety of surface treatment but presents the artist's familiar image with a new power derived from the changed relationship of image, ground, and execution.

In the lithographic treatments of the bathrobe a similar progression in technical expertise appears, but related to the artist's peculiar use of crayon and tusche, the tools of the medium. The soft and reliable grease crayon allowed a continuous unvarying line to define the contours of *Eleven Part Self Portrait (Red Pony)*, the first lithograph version of the theme, created in 1965 at Tatyana Grosman's Universal Limited Art Editions in West Islip, New York. The outline was augmented by touches of liquid tusche (a greasy lithographic ink) that was printed in red. Unlike the scratches of the etching needle and the manipulated ground and acid textures, the marks Dine made in his lithographs were less harsh and even the bloody red washes evoked the pleasant watercolors of his rainbows and hearts. The *Eleven Part Self Portrait* was also the largest print Dine had made up to that time. The bathrobe, always prepossessing as a symbol, became monumental in lithography. The three lithograph bathrobes made at Petersburg Press in 1969, like the etched versions of 1972, use identical outlines, but are filled with: 1. a colorful landscape, 2. a luscious red wash, and 3. in *Night Portrait*, the blackness of the paper itself. In this last lithographic robe Dine chose to have the outline printed in white on black paper. This austere concept appeared earlier in *Night Palette* (1965) and later in *Self Portrait as a Negative* (1975), the first instance of its use in etching. The 1969 bathrobes encompassed Dine's approach to lithography as a medium that gave him a scale nearer to that of his combine paintings and a surface and tools that were amenable to his natural agility as a watercolorist and draughtsman.

As in his unique works which often combine objects and painted canvas, Dine occasionally adds watercolor to his black and white prints, collages material to silkscreens and lithographs, and uses more than one print medium in a single print. After a visit to the Edvard Munch Museum in Oslo Dine was fascinated by Munch's jig-saw puzzle style of making woodcuts. The *Woodcut Bathrobe* of 1975 is created from twelve cut-out wood pieces united by a black lithographic outline. The widest ranging example of Dine's freedom from the constraints of one medium is *The World (for Anne Waldman)* of 1971, a combination of color lithography, silkscreen, block print, and pencil. The relatively few times Dine has used silkscreen he has called upon its capacity to produce photographic images, hard-edged unmodulated color, and other of its mechanical qualities that evoke contemporary commercial printing technology. Dine's first silkscreens (or screenprints, since synthetics have long ago replaced silk) were three prints made for the albums *11 Pop Artists* (1965). The banal photographic imagery in one of the prints included a pack of Marlboro cigarettes (Pop Art's favorite brand). In 1966 he worked with Christopher Prater, the British master of screenprinting, on a portfolio of ten screenprints with collage titled *A Tool Box*. The photographic representations of objects in these and the previous screenprints appeared to validate the opinion that Dine was a Pop Artist, since the personal response of the artist to

the object was apparently replaced by a mechanical one. These few instances of a "cool" involvement with the object which carried over into his mammoth etching *Drag—Johnson and Mao* (1967) and pervaded his early work in London mark a period of change for Dine that undeniably was influenced by his associations with artists such as Eduardo Paolozzi and R. B. Kitaj. Screenprinting did not have a lasting appeal for Dine, and since the late 1960's he has used it mainly to augment more autographic media.

Dine is a character artist. His illustrations for books, designs for theatre, and portraits detail the outward traits of the individual personna of the story or drama rather than depict events in which they are participants. Dine said, "Many of the objects are presences on this stage I've made." (quoted by Victor Coleman, "Look at my product; notes, more or less specific on Jim Dine." *Artscanada.* Vol. 27. December 1970, pp. 50-51.) Many of the dramas that take place on Dine's stage can only be imagined from the costumes, poses, and signs he gives to his characters. The costume drawings for *A Midsummer Night's Dream* (1965) were only the practical realization of his already established form of making exterior attributes stand for character. The illustrations for *The Picture of Dorian Gray* (1968) which could have easily been narrative were, instead, the clothing and objects that alluded to fictional events in much the same manner as selected elements of vocabulary would give clues to an answer to a riddle. A character is a language sign as much as it is a figure in drama or life. Dine has substituted objects for human characters in *Flaubert Favorites,* a series of four lithographs on Nepalese paper, completed in 1972. A fan, a wrench, and a wrench and brush are given, as titles, the names of three Flaubert characters. The objects may be read as punning remarks about the characters for whom they stand or may be object substitutions for physical types. Dine is a visual ventriloquist who suggests more than he presents. After tricking us into accepting the object as human, he transforms himself into a character *From an Undefined Novel.* The eight plates from this recent suite of handcolored etchings published by Pyramid Arts, Ltd. in Tampa, Florida, depict eight characters in search of a story. Each is the archetypal participant in an international mystery of intrigue. Most provocative is the portrayal of the artist, himself, as two of the characters: "Cher Maître" and "The Die-Maker." The ventriloquist's illusion is complete. Much has been made of Dine's Cincinnati childhood, at play amongst the myriad objects of his grandfather's hardware store, at work with the housepaint and plumbing fixtures at his father's store. No less an animator of objects than the Sorcerer's Apprentice, Dine has devoted most of his career to man-made things isolated from their normal function and habitat. Although most of his recent etchings of himself share this isolation, a new poetry is in the works. The subjective object is now in the powerful hand of "The Die-Maker."

July, 1976

CATALOGUE
RAISONNÉ

This catalogue documents all of Jim Dine's prints since 1969, and complements the *Jim Dine:Complete Graphics* catalogue published by the Galerie Mikro in Berlin in 1970. The two volumes represent a complete documentation of all of Jim Dine's prints to date. In this volume, the listing of the prints is chronological with two exceptions: 1) where the publishing date postdates the completion of the print, the print is listed by completion date, where it more logically fits in the artist's oeuvre, and 2) *The Dartmouth Portraits*, catalogue numbers 184-192, are reworked versions of the same plates used in *Self Portraits (1971)* catalogue numbers 47-55. Although the prints are numbered chronologically, the earlier series appears in the catalogue adjacent to the later series under the later date for purposes of comparison.

Process descriptions of selected prints are included only in instances where either the normal documentation or the photograph does not clearly explain an unusual technique, or where there is process information of a special nature.

The information on edition records is as complete as each respective publisher was able to provide.

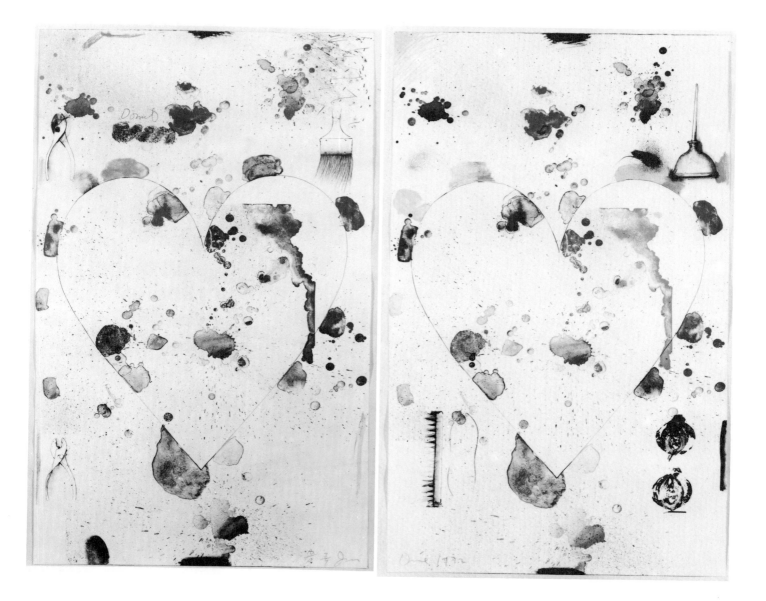

2 Hearts (The Donut) 1970 1
Diptych lithograph from twelve stones and eight plates
Printed in eleven colors on two sheets of 137.2 x 81.3
cm (54 x 32 inch) J. Whatman paper
Edition record: 17
 plus Artist's Proofs
Published in 1972 by Universal Limited Art Editions,
West Islip, Long Island; printed by William Goldston
Signed and dated, across both sheets, lower edge,
center

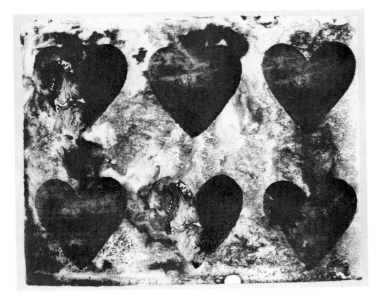

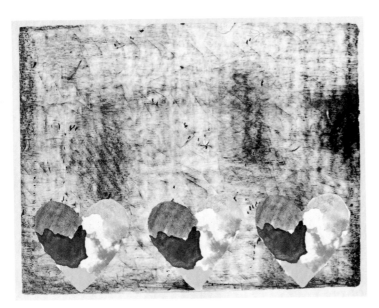

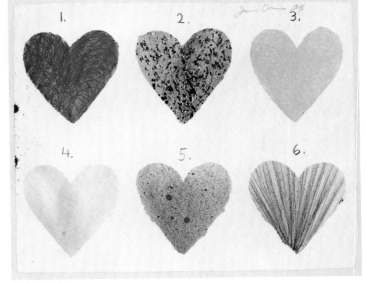

Dutch Hearts 1970 2-9
Portfolio of eight lithographs from zinc plates
Printed in color with collage on sheets of 40.6 x 50.8
cm (16 x 20 inch) Hodgkinson Hand Made paper,
watermarked with the initials of both the artist and
Petersburg Press
Edition record: 85
 15 Artist's Proofs
Published by Petersburg Press, London; printed by Piet
Clement, Amsterdam
Signed and dated, upper edge, right

In each print, the hearts were torn from paper printed
with crayon marks, washes, or textures, and collaged to
the 40.6 x 50.8 cm (16 x 20 inch) Hodgkinson paper.

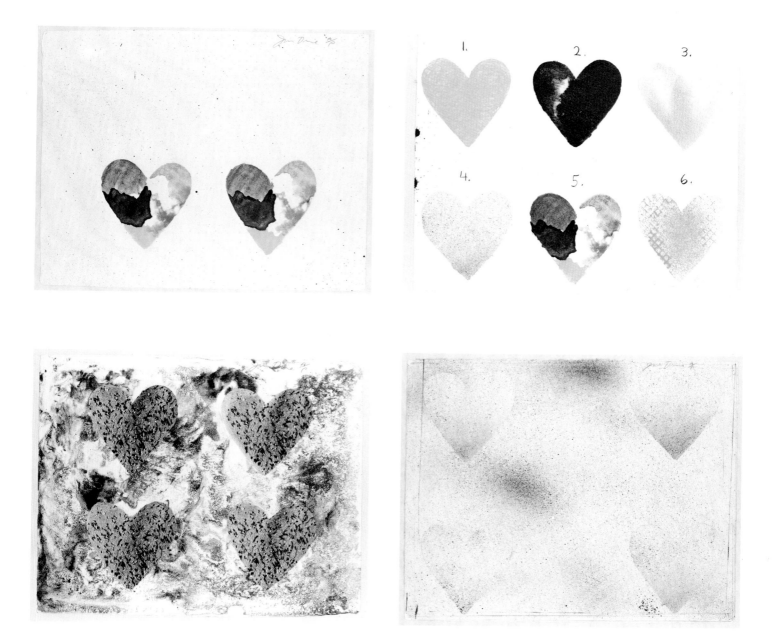

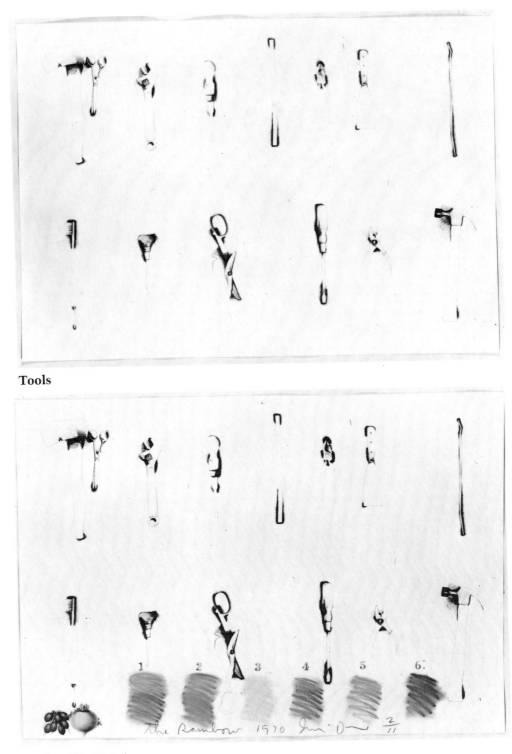

Tools

Tools—The Rainbow

Tools 1970 10
Lithograph offset from one zinc plate
Printed in black on sheet of 101.6 x 140.3 cm (40 x
55¼ inch) Hodgkinson Mould Made paper
Edition record: 63
 8 Artist's Proofs
Published by Petersburg Press, London; printed by
Ernie Donagh
Signed and dated, lower edge, right

Tools—The Rainbow 1970 11
Lithograph offset from one zinc plate, the same plate as
Tools
Printed in black on sheet of 101.6 x 140.3 cm (40 x
55¼ inch) Hodgkinson Hand Made paper with collage,
hand coloring in pastel, and hand stamped numerals
by the artist after editioning
Edition record: 11
 no Artist's Proofs
Published in 1972 by Petersburg Press, London;
printed by Ernie Donagh
Signed and dated, lower edge, center

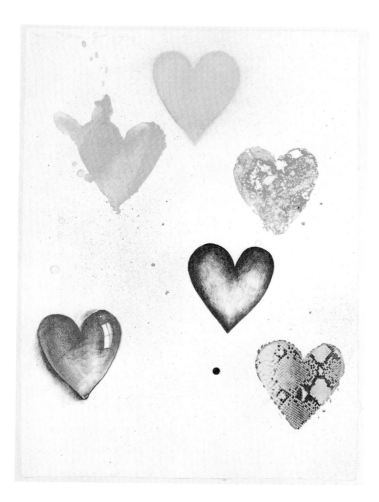

Six Hearts 1970 12
Lithograph offset from six zinc plates
Printed in six colors on sheet of 76.2 x 55.9 cm (30 x
22 inch) Crisbrook Waterleaf paper with collage, spray
painting, and hand painting in tempera by the artist after
editioning
Edition record: 79
 20 Artist's Proofs
Published by Petersburg Press, London; printed by
Ernie Donagh
Signed and dated, upper edge, left

Hammers 1970 13
Diptych lithograph offset from two
zinc plates
Printed in black on two sheets of
66.0 x 40.6 cm (26 x 16 inch)
orange Hodgkinson Hand Made
paper
Edition record: 53
 10 Artist's Proofs
Published by Petersburg Press,
London; printed by Ernie Donagh
Signed and dated, across both sheets,
lower edge, center

Self Portrait (stencil) 1970

Stencil

Image printed in twelve colors and collaged to sheet of
152.4 x 101.6 cm (60 x 40 inch) Hodgkinson Mould
Made paper

Edition record: 17

 4 Artist's Proofs

Published by Petersburg Press, London; printed by
Maurice Payne

Signed and dated, upper edge, left

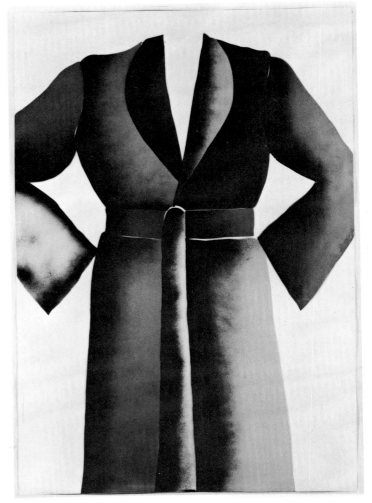

Self Portrait (stencil)

A Painted Self Portrait 1970 15

Stencil

Printed in twelve colors on sheet of 152.4 x 101.6 cm
(60 x 40 inch) Hodgkinson Mould Made paper, hand
colored with charcoal and paint by the artist after
editioning

Edition record: 7 Variants

Published in 1973 by Petersburg Press, London; printed
by Maurice Payne

Signed and dated, across upper edge

In these stencil prints, Dine drew the outline of the
bathrobe on a large sheet of masonite. The printer,
Maurice Payne, had the masonite cut along the lines of
the drawing. The masonite "puzzle" was placed over a
large sheet of paper and, as each section was lifted one
at a time, paint was sprayed through the stencil
opening. After each section had been lifted and spray
painted, the robe was cut along the outlines and
collaged to a large sheet of Hodgkinson Mould Made
paper. *A Painted Self Portrait* was a second edition
of seven, hand drawn and painted directly on the print
by Dine.

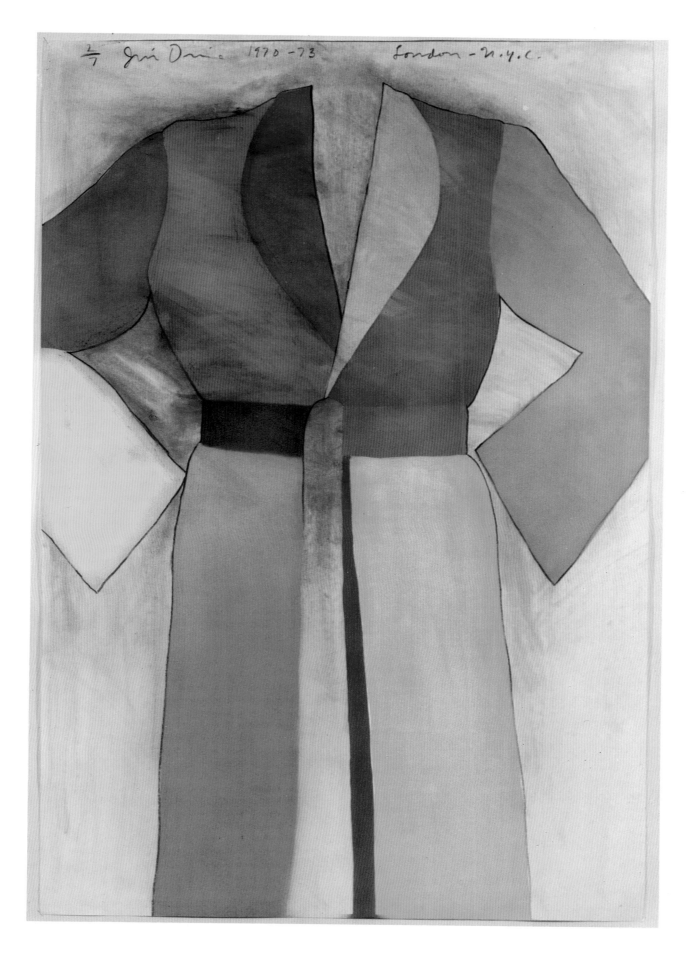

A Painted Self Portrait

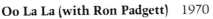

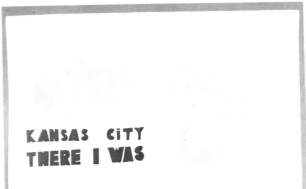

Oo La La (with Ron Padgett) 1970 16-30

Portfolio of fifteen lithographs offset from zinc plates, drawn by both artists

Printed in color on sheet of 43.2 x 69.9 cm (17 x 27½ inch) Hodgkinson Hand Made paper, watermarked with the signatures of the artists together with the initials of Petersburg Press

Edition record: 75
 15 Artist's Proofs

Published in 1972 by Petersburg Press, London; printed by Ernie Donagh

Signed and numbered by both artists, across lower edge

The portfolio is encased in a silk bound box printed with pink pigs. A title page and final page with a description of the project are also included.

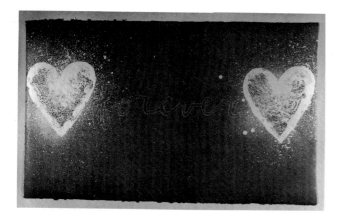

Supernatural overtones
OVERTONES

"The old professor tapped his finger against his forehead. "I want you to consider the proposition that there is supernatural activity going on in the intellectual space between any two words. Example: two words. It is as though... as if each word, with its richness of connotation and suggestion, multiplied by our unconscious notions (true and false alike), were two sides of a chasm within which the echoes and ricochets approach and then surpass infinity...."

The Poet Assassinated 1970

Etching from one 70.5 x 54.6 cm (27¾ x 21½ inch)
copper plate

Printed in black on sheet of 88.9 x 71.1 cm (35 x 28 inch)
J. Green Mould Made paper, hand painted with water
color by the artist after editioning, title in block print

Edition record: 75

 15 Artist's Proofs

Published in 1971 by Petersburg Press, London; printed
by Maurice Payne

Signed and dated, below impression, left

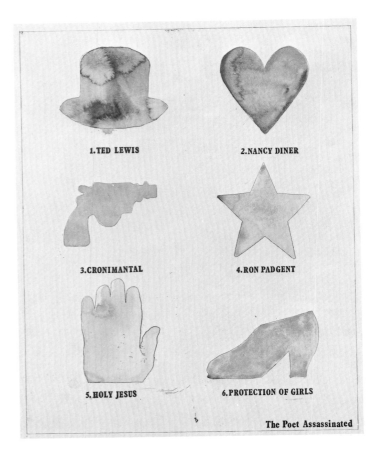

The Realistic Poet Assassinated 1970

Etching from one 70.5 x 54.6 cm (27¾ x 21½ inch)
copper plate

Printed in black on sheet of 88.9 x 71.1 cm (35 x 28
inch) J. Green Mould Made paper, hand painted with
water color by the artist after editioning

Edition record: 75

 15 Artist's Proofs

Published in 1971 by Petersburg Press, London; printed
by Maurice Payne

Signed and dated, below impression, left

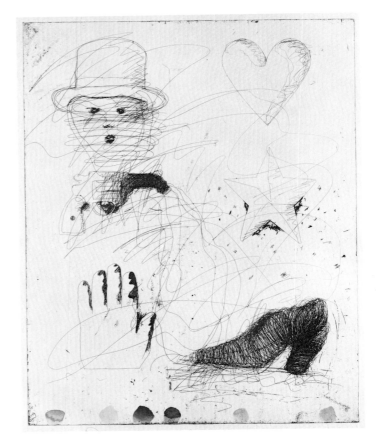

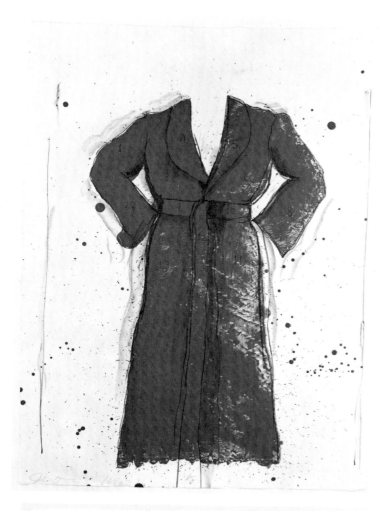

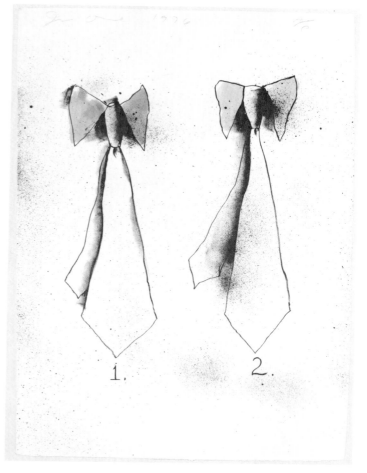

Bathrobe, Hands, Ties, Saw,
Rainbow, Boots 1970 33-35
Portfolio of six lithographs begun in 1970 of which
Bathrobe, Hands, and *Ties* were editioned as a set of
three in 1976

Edition record: 150
 10 Artist's Proofs

To be published by Petersburg Press, London; printed
by Ernie Donagh
Signed and dated

Bathrobe

Lithograph offset from two zinc plates
Printed in two colors on sheet of 81.3 x 59.1 cm (32 x
23¼ inch) J. Green Penhurst paper

Hands

Lithograph offset from five zinc plates
Printed in five colors on sheet of 76.2 x 55.9 cm (30 x 22
inch) Crisbrook Waterleaf paper, title inscribed in ink
by the artist after editioning

Ties

Lithograph offset from zinc plates
Printed in black on sheet of 76.2 x 55.9 cm (30 x 22
inch) Crisbrook Waterleaf paper, hand painted by the
artist with water color after editioning

Girl and Her Dog I

Girl and Her Dog II

K.

A.

J.

E.

D.

C.

B.

F.

G.

H.

hearts.

I.

The World (for Anne Waldman)

A Girl and Her Dog I 1970 36

Etching from one 69.9 x 54.6 cm (27½ x 21½ inch)
copper plate

Printed in black with aquatint in red on sheet of 88.9 x
71.1 cm (35 x 28 inch) J. Green Mould Made paper

Edition record: 75

 15 Artist's Proofs

Published in 1971 by Petersburg Press, London;
printed by Maurice Payne

Signed and dated, below impression, right

A Girl and Her Dog II 1971 37

Etching from one 69.2 x 54.0 cm (27¼ x 21¼ inch)
copper plate

Printed in black on sheet of 88.9 x 71.1 cm (35 x 28
inch) J. Green Mould Made paper with reverse
embossed heart hand painted in water color by the
artist after editioning

Edition record: 75

 16 Artist's Proofs

Published by Petersburg Press, London; printed by
Maurice Payne

Signed and dated, below impression, right

The World (for Anne Waldman) 1971 38

Lithograph from zinc plates

Printed in eleven colors with screen and block printing
on sheet of 76.2 x 101.6 cm (30 x 40 inch) Hodgkinson
Hand Made paper, watermarked with the initials of both
the artist and Petersburg Press with collage and various
titles written in pencil by the artist after editioning

Edition record: 100

 10 Artist's Proofs

Published in 1972 by Petersburg Press, London;
proofed by Ernie Donagh, editioned by Richard Stone
and Valerie Pedlar

Signed and dated, lower edge, right

Four Kinds of Pubic Hair 1971 39-42

Set of four etchings, each from one 29.2 x 21.6 cm (11½
x 8½ inch) copper plate

Printed in black on sheet of 58.4 x 40.6 cm (23 x 16
inch) F. J. Head Hand Made paper

Edition record: 50

 10 Artist's Proofs

Published by Petersburg Press, London; proofed and
editioned by Maurice Payne

Signed and dated, lower edge, right

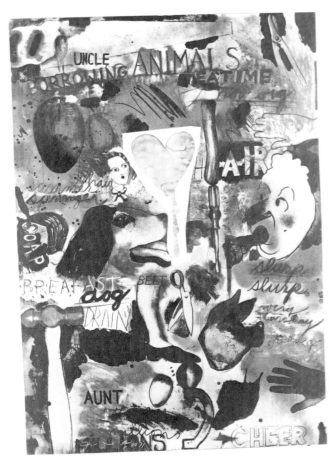

Picabia I (Cheer)

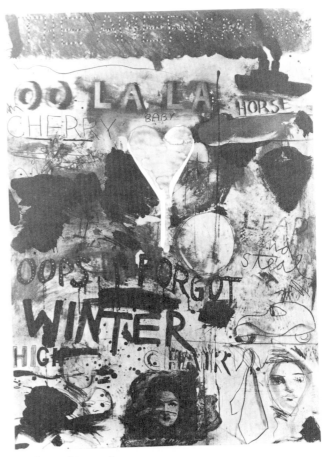

Picabia II (Forgot)

Picabia I (Cheer) Picabia II (Forgot)
Picabia III (Groans) 1971 43-45
Three lithographs, each from one zinc plate,
handworked by the artist over half-tone images
Printed in black on sheet of 139.7 x 101.6 cm (55 x 40
inch) Hodgkinson Mould Made paper with collage
added by the artist after editioning
Edition record: 75
 15 Artist's Proofs
Published by Petersburg Press, London; printed by
Ernie Donagh
Signed and dated, lower edge, center

The heart in the center of each print is a collage printed
in red from a photolithograph of a wash drawing.

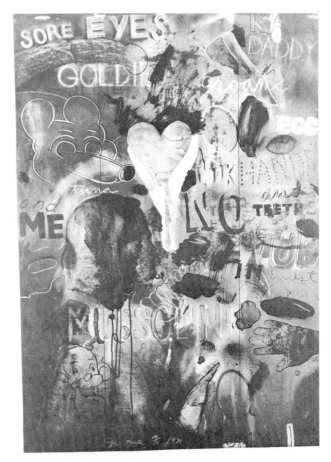

Picabia III (Groans)

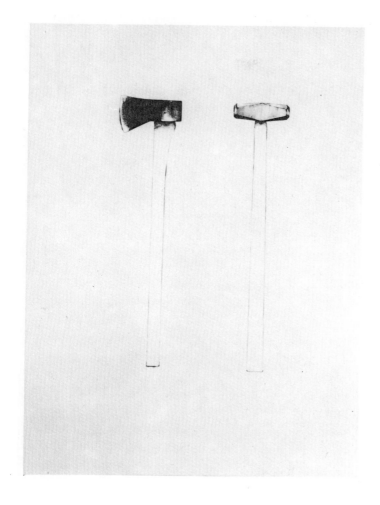

Sledgehammer and Axe 1971 46
Lithograph offset from one zinc plate
Printed in black on sheet of 140.3 x 101.6 cm (55¼ x
40 inch) Hodgkinson Mould Made paper
Edition record: 80
 12 Artist's Proofs
Published by Petersburg Press, London; printed by
Ernie Donagh
Signed and dated, lower edge, center

Scissors and Rainbow (reworked) 1971 56
Lithograph from zinc plates
Printed in seven colors on sheet of 91.4 x 63.5 cm (36 x
25 inch) BFK Rives paper, hand colored with crayon
by the artist after editioning
Edition record: 6
 no Artist's Proofs
Published by Petersburg Press, London; printed by
Ernie Donagh
Signed and dated, lower edge, right

Scissors and Rainbow was proofed in an edition of six,
and was originally intended to be a larger print.
However, the edition was inadvertently burned on a
hot plate in a hotel room in New York City. Dine had
the burned bottom portions cut off and hand colored
the six prints to balance the change in dimension.

The series, *Self Portraits (1971)*, catalogue numbers 47-55,
appears adjacent to *Self Portraits-second published state
(the Dartmouth Portraits)*, catalogue numbers 184-192.

Etching, Self Portrait (primary colors) 1969-1972 57

Etching from three 29.2 x 21.6 cm (11½ x 8½ inch) copper plates

Printed separately in blue, yellow, and red on sheet of 55.9 x 76.2 cm (22 x 30 inch) Hodgkinson Hand Made paper, watermarked with the artist's name together with the initials of Petersburg Press

Edition record: 75
 15 Artist's Proofs

Published by Petersburg Press, London; printed by Maurice Payne
Signed and dated, lower edge, left

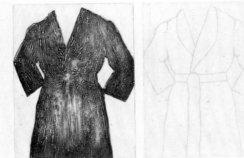

Etching, Self Portrait (ivory) 1969-1972 58

Etchings from three 29.9 x 21.6 cm (11½ x 8½ inch) copper plates, the same plates as in *Etching, Self Portrait (primary colors)*

Printed separately in black on sheet of 55.9 x 76.2 cm (22 x 30 inch) Hodgkinson Hand Made Ivory-Wove paper, watermarked with the artist's name together with the initials of Petersburg Press

Edition record: 15
 5 Artist's Proofs

Published by Petersburg Press, London; printed by Maurice Payne
Signed and dated, below impression, right

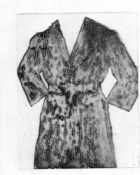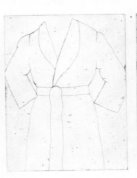

Etching, Self Portrait (red) 1969-1972 59

Etching from three 29.9 x 21.6 cm (11½ x 8½ inch) copper plates

Printed separately in black on sheet of 55.9 x 76.2 cm (22 x 30 inch) Hodgkinson Hand Made Red-Wove paper, watermarked with the artist's name together with the initials of Petersburg Press

Edition record: 75
 5 Artist's Proofs

Published by Petersburg Press, London; proofed by Hartmut Freilinghaus and editioned by Maurice Payne
Signed and dated, below impression, right

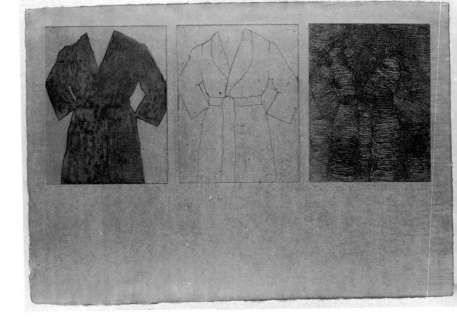

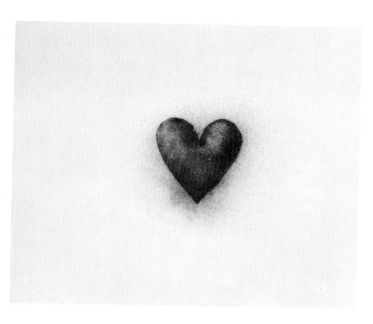

Black Heart 1971 60
Lithograph from one zinc plate
Printed in black on sheet of 76.2 x 101.6 cm (30 x 40 inch) mylar
Edition record: 55
 10 Artist's Proofs
Published by Petersburg Press, London; printed by Ernie Donagh
Signed and dated, lower edge, center

Colors and Flower 1973 61
Etching from one 15.2 x 20.3 cm (6 x 8 inch) copper plate
Printed in black on sheet of 40.6 x 50.8 cm (16 x 20 inch) Hodgkinson Hand Made paper, hand painting with water color by the artist after editioning
Edition record: 14
 5 Artist's Proofs
Published by Petersburg Press, New York; printed by Maurice Payne
Signed and dated, with title inscribed below impression, center

Morning Glory 1972 62
Two prints:
Etching from one 15.2 x 20.3 cm (6 x 8 inch) copper plate, the same plate as *Colors and Flower*
Lithograph offset from zinc plates with screen printing
Etching printed in black
Lithograph and screen print printed in color on two sheets of 19.1 x 24.1 cm (7½ x 9½ inch) Hodgkinson Mould Made paper
Edition record: 47
 4 Artist's Proofs
Published by Petersburg Press, London; printed by Maurice Payne and Christopher Betambeau
Signed and dated, below etched impression, center

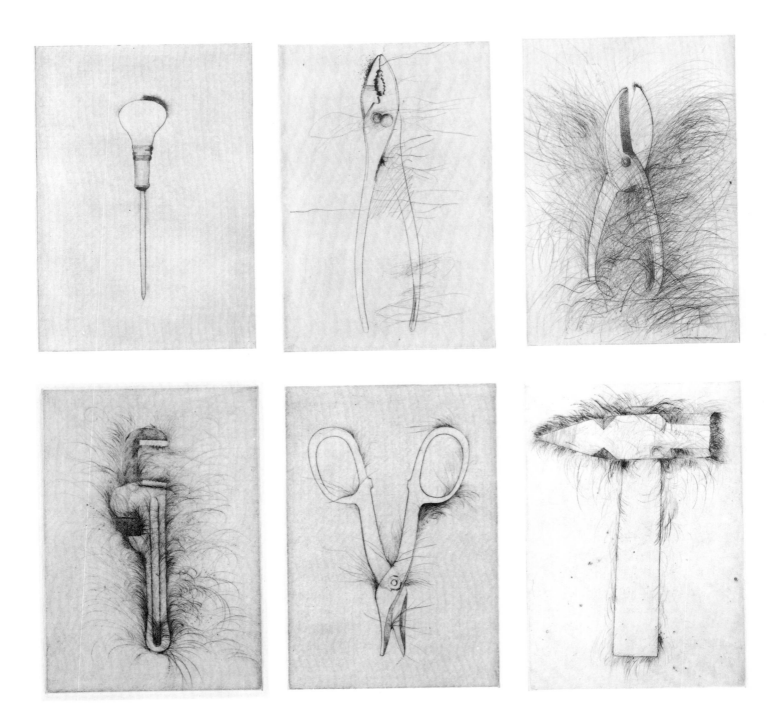

Thirty Bones of My Body 1972 63-92

A portfolio of thirty drypoints, each from one 22.9 x 15.2
cm (9 x 6 inch) copper plate

Printed in black on sheet of 76.2 x 55.9 cm (30 x 22 inch)
Crisbrook Waterleaf paper

Edition record: 10
 3 Artist's Proofs

Published by Petersburg Press, London; printed by
Maurice Payne

Signed and dated, lower edge, center

This portfolio of thirty prints is boxed in an olive green
leather case.

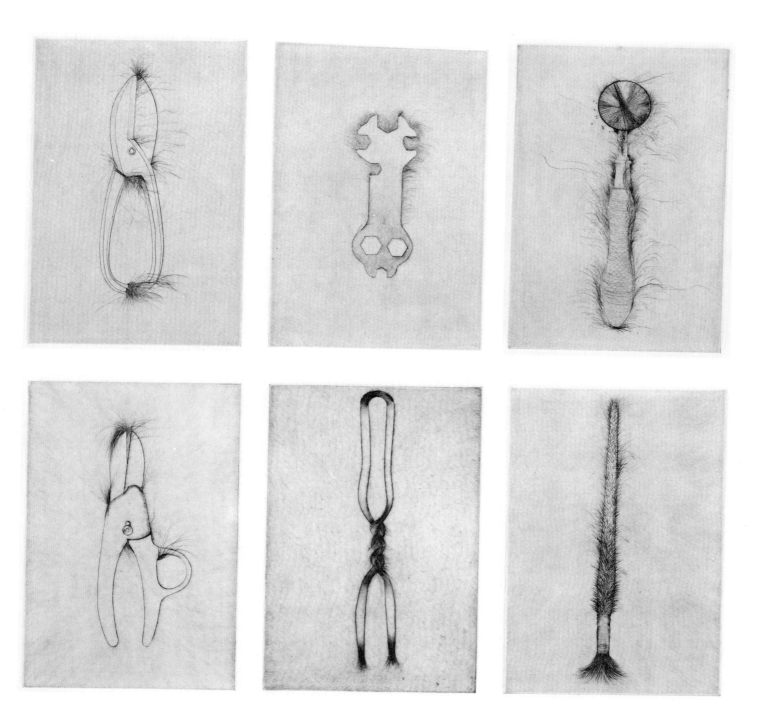

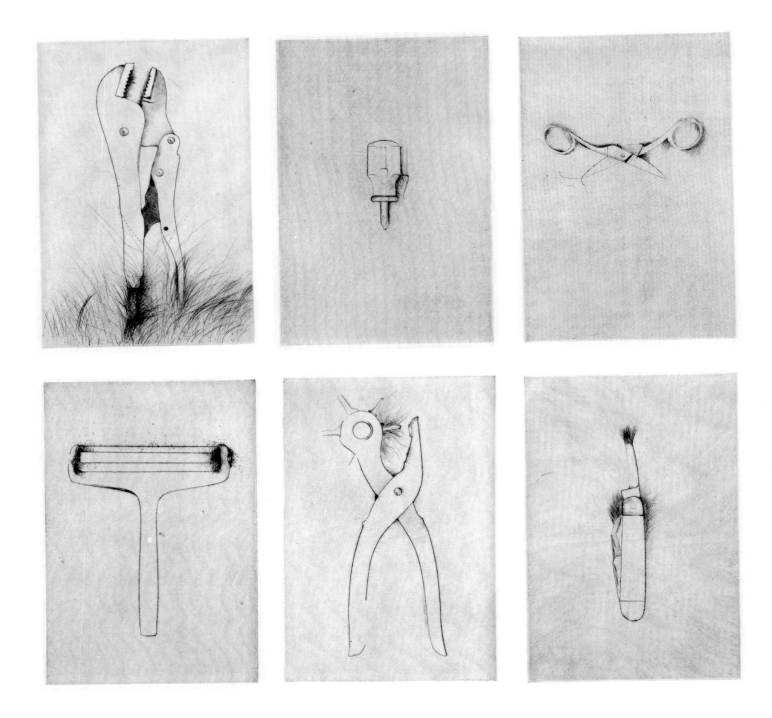

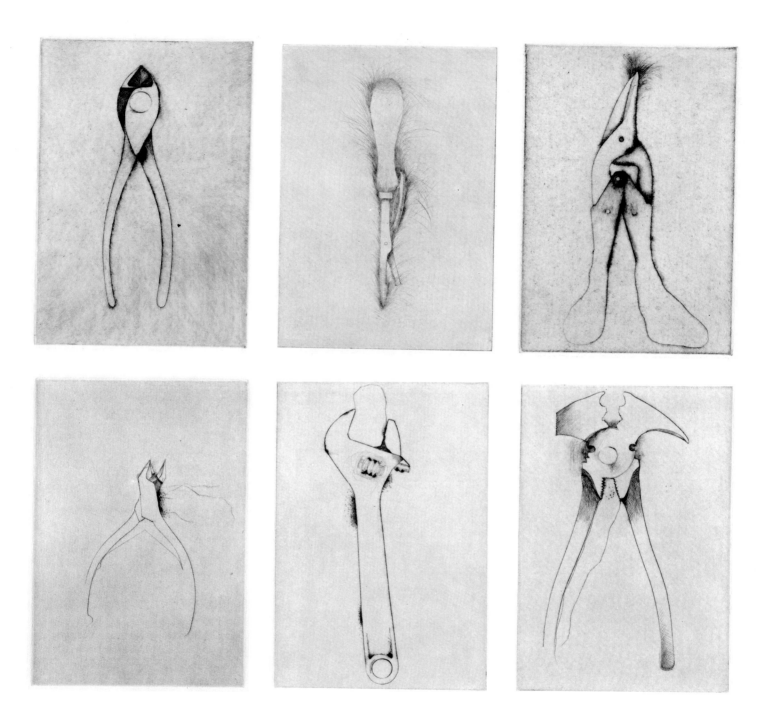

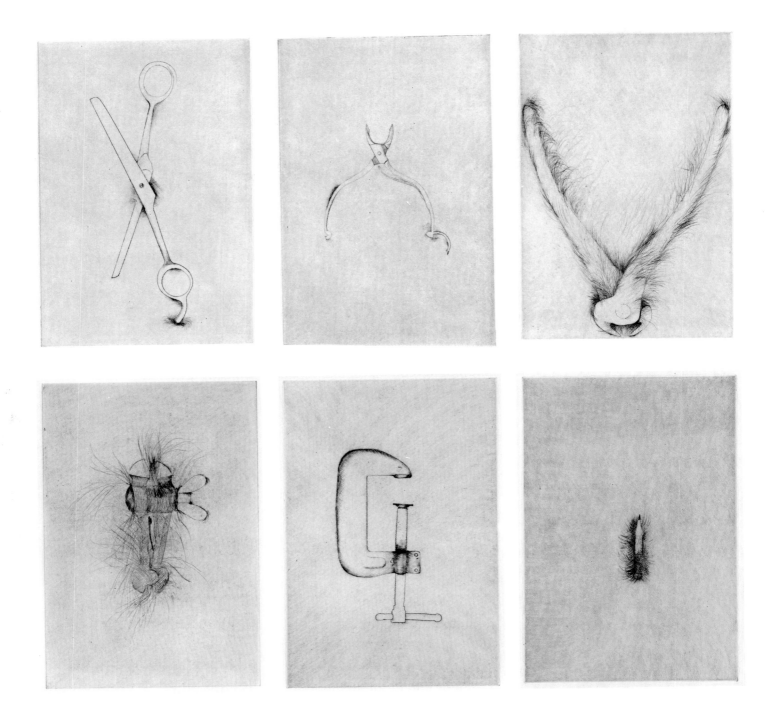

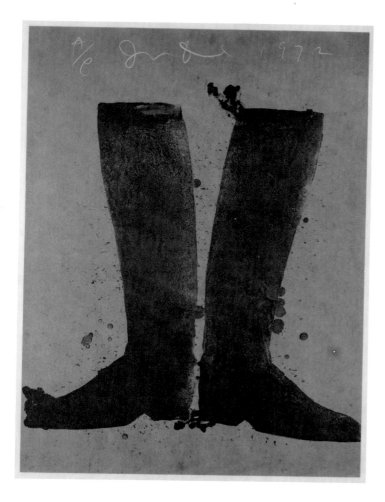

Silhouette Black Boots on Brown Paper 1972 93

Lithograph from one zinc plate
Printed in black on sheet of 81.3 x 55.9 cm (32 x 22 inch) Commercial Wrapping Cartridge
Edition record: 100
 20 Artist's Proofs
Published by Petersburg Press, London and Gérald Cramer Gallery, Geneva; printed by Ernie Donagh
Signed and dated, across upper edge

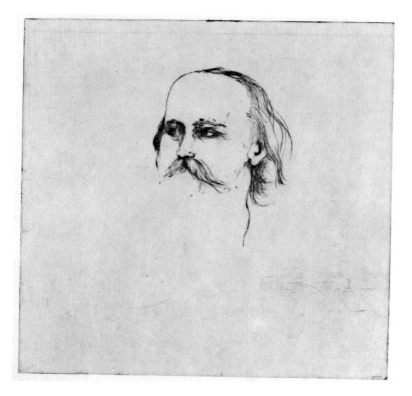

Gustave Flaubert 1972 94

Drypoint from one 27.9 x 30.5 cm (11 x 12 inch) copper plate
Printed in black on sheet of 76.2 x 55.9 cm (30 x 22 inch) Crisbrook Waterleaf paper
Edition record: 25
 4 Artist's Proofs
Published by Petersburg Press, London; printed by Hartmut Freilinghaus
Signed and dated, below impression, center

Dine worked with roofer's copper for the first time in this drypoint. Roofer's copper is a thin metal plate normally used in the construction industry. Its unpolished surface comes with numerous scratches and plate marks. Dine drew on the plate from a photograph of Flaubert.

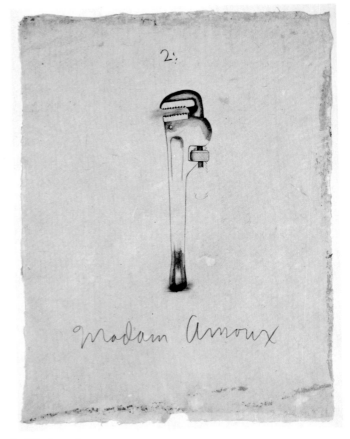

1. The Marshal

Flaubert Favorites (Edition A) 1972 95-98

A suite of four lithographs, each from one zinc plate

Printed in black on sheet of 66.0 x 50.8 cm (26 x 20 inch) Hand Made Nepalese paper

Edition record: 8

plus Artist's Proofs

Published by Universal Limited Art Editions, West Islip, Long Island; printed by Zigmunds Priede

Signed and dated, lower edge, right

The single sheet of paper for each *Flaubert Favorite* is actually three pieces of laminated waxed paper used as window panes in Nepal. Tatyana Grosman obtained the paper from a Swiss paper dealer.

Flaubert Favorites (Edition B) 1972 99-102

Four lithographs, each from one zinc plate, the same plates as in *Flaubert Favorites (Edition A)*

Printed in black on sheet of 76.2 x 55.9 cm (30 x 22 inch) Arches paper

Edition record: 18

plus Artist's Proofs

Published by Universal Limited Art Editions, West Islip, Long Island; printed by Zigmunds Priede

Signed and dated

2. Madam Arnoux

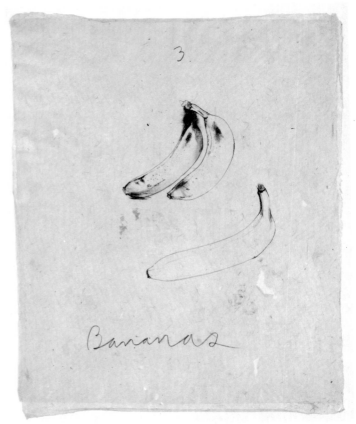

3. Bananas

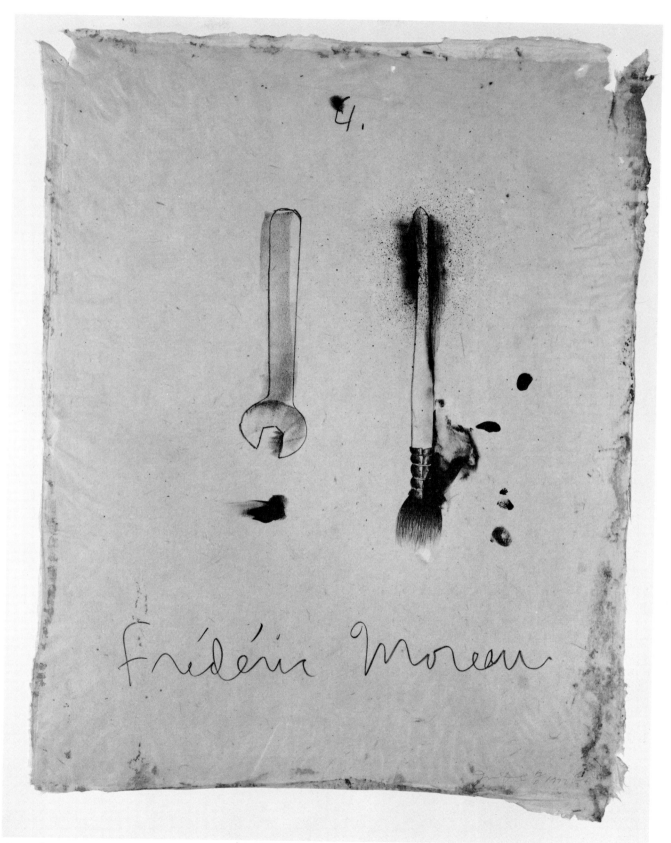

4. Frédéric Moreau

Shoe (first state) 1973 103

Etching from one 50.8 x 66.0 cm (20 x 26 inch)
copper plate
Printed in black on sheet of 106.7 x 76.2 cm (42 x 30
inch) blue Hodgkinson Hand Made paper
Edition record: 19
 2 Artist's Proofs
Published by Petersburg Press, London; printed by
Maurice Payne
Signed and dated, below impression, center

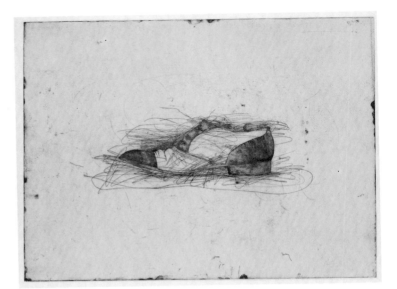

Shoe (second state) 1973 104

Etching from one 50.8 x 66.0 cm (20 x 26 inch)
copper plate
Printed in green on sheet of 61.0 x 73.7 cm (24 x 29
inch) Japanese Etching paper
Edition record: 30
 5 Artist's Proofs
Published by Petersburg Press, London; printed by
Hartmut Freilinghaus and Maurice Payne
Signed and dated, below impression

Shoe (third state) 1973 105

Etching from one 50.8 x 66.0 cm (20 x 26 inch)
copper plate
Printed in black on sheet of 55.9 x 76.2 cm (22 x 30
inch) Copperplate Deluxe paper
Edition record: 15
 4 Artist's Proofs
Published by Petersburg Press, London; printed by
Hartmut Freilinghaus
Signed and dated, below impression, left

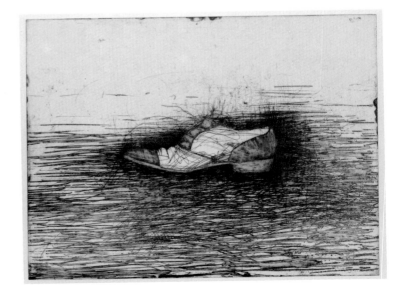

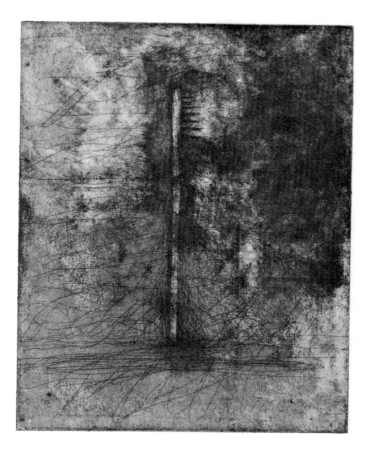

Toothbrush 1973 106

Etching from one 25.1 x 19.4 cm (9⅞ x 7⅝ inch) zinc plate

Printed in black on sheet of 55.9 x 45.7 cm (22 x 18 inch) HMP #3 Rough White paper

Edition record: 35
 10 Artist's Proofs

Published by Petersburg Press, New York; printed by Alan Uglow and Winston Roeth

Signed and dated, below impression, center

For this print, Dine had a drawing of a toothbrush photomechanically reproduced on a zinc plate. He then reworked the plate with hard ground and acid.

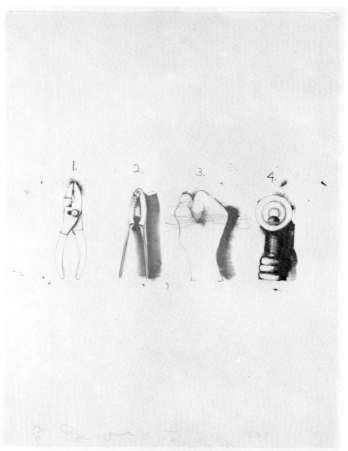

Nutcracker 1973 107

Lithograph from one aluminum plate

Printed in four colors on sheet of 76.2 x 55.9 cm (30 x 22 inch) Arches Cover Buff paper

Edition record: 100
 10 Printer's Proofs
 10 Artist's Proofs

Published by Petersburg Press, New York and Dayton's Gallery 12, New York; printed by William Law

Signed and dated, across lower edge

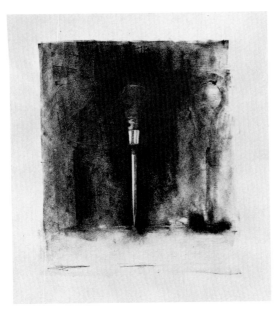

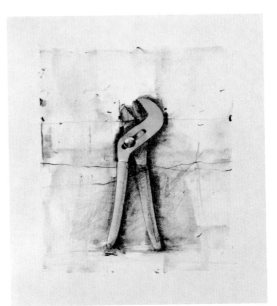

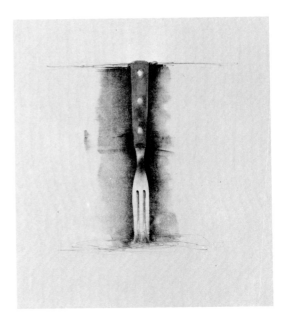

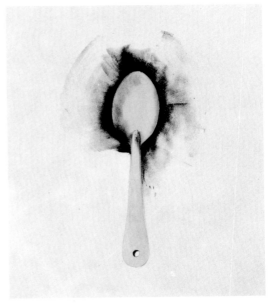

Ten Winter Tools 1973 108-117

A suite of ten lithographs, nine from aluminum plates, one from zinc

Printed in black on sheet of 76.2 x 55.9 cm (30 x 22 inch) German Etching Deluxe paper

Edition record: 100
 10 Printer's Proofs
 10 Artist's Proofs

Published by Petersburg Press, New York; printed by William Law
Signed and dated

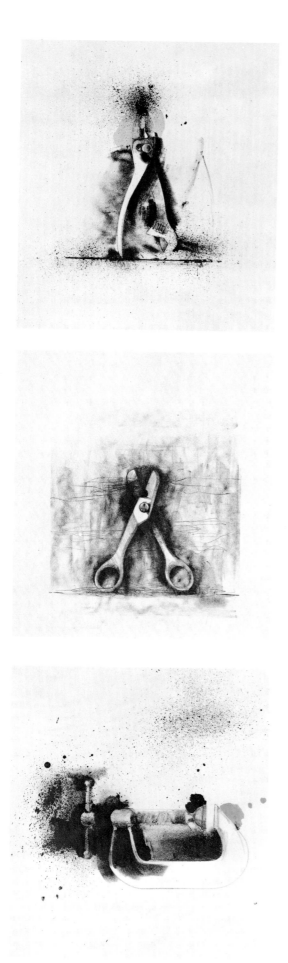

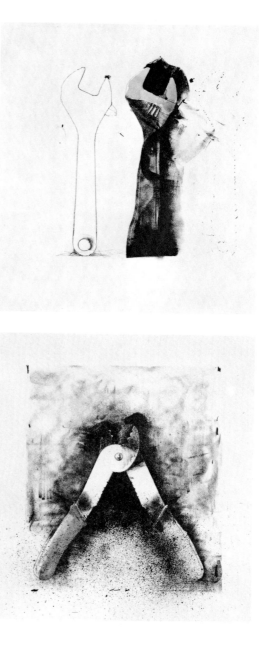

Ten Winter Tools (hand colored) 1973 118-127

A suite of ten lithographs from the same aluminum
and zinc plates as *Ten Winter Tools*

Printed in black on sheet of 66.0 x 50.8 cm (26 x 20
inch) Auvergne Narcisse paper with hand coloring in
water color by the artist after editioning

Edition record: 10
 4 Artist's Proofs

Published by Petersburg Press, New York; printed by
William Law

Signed and dated

The hand coloring distinguishes this set from the
preceding suite of *Ten Winter Tools.*

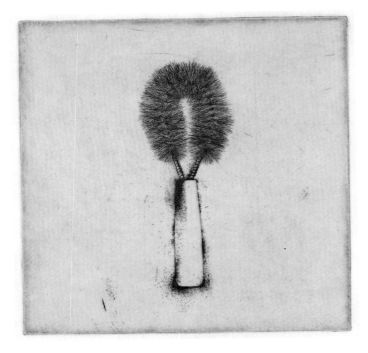
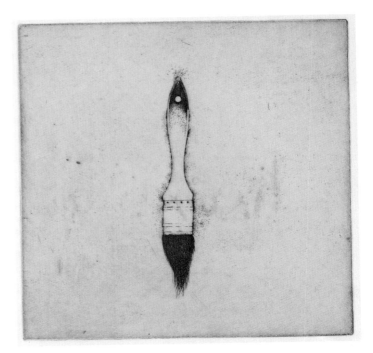
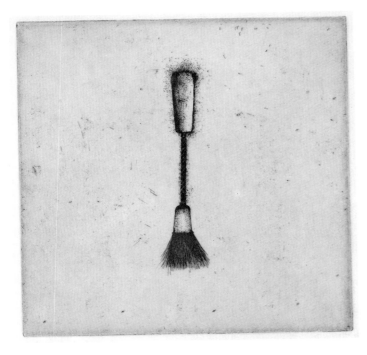
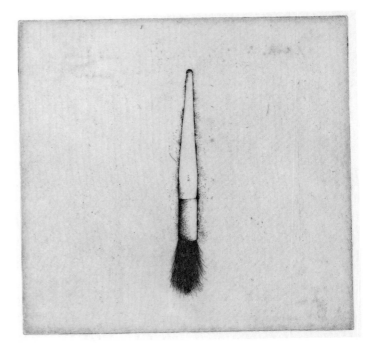

Four German Brushes 1973 128-131
Suite of four etchings, each from one 30.5 x 30.5 cm (12
x 12 inch) copper plate
Printed in black on sheet of 76.2 x 55.9 cm (30 x 22
inch) Crisbrook Waterleaf paper
Edition record: 75
 12 Artist's Proofs
Published by Petersburg Press, London; printed by
Maurice Payne
Signed and dated, across lower edge

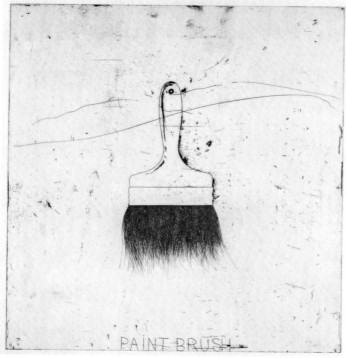

Paintbrush

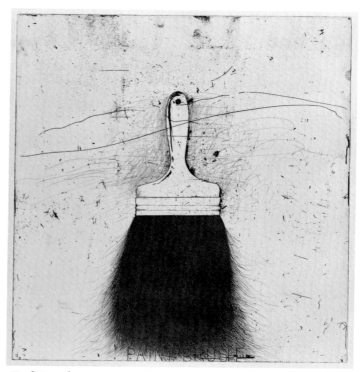

Red Beard

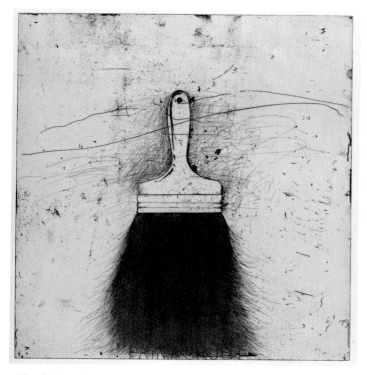

Black Beard

Paintbrush 1971 132

Etching from one 53.7 x 50.2 cm (21 x 20 inch)
copper plate

Printed in black on sheet of 88.9 x 71.1 cm (35 x 28
inch) J. Green Mould Made paper

Edition record: 75

 15 Artist's Proofs

Published by Petersburg Press, London; printed by
Maurice Payne

Signed and dated, lower edge, left

Black Beard 1973 133

Etching from one 53.6 x 50.2 cm (21 x 20 inch)
copper plate

Printed in black on sheet of 106.7 x 76.2 cm (42 x 30
inch) J. Green Mould Made paper

Edition record: 50

 10 Artist's Proofs

Published by Petersburg Press, London; printed by
Maurice Payne

Signed and dated, lower edge, center

The plate for *Paintbrush* printed in 1971 was reworked
in 1973 for *Black Beard* and *Red Beard.*

Red Beard 1973 134

Etching from one 53.6 x 50.2 cm (21 x 20 inch)
copper plate

Printed in red on sheet of 106.7 x 76.2 cm (42 x 30 inch)
J. Green Mould Made paper

Edition record: 50

 10 Artist's Proofs

Published by Petersburg Press, London; printed by
Maurice Payne

Signed and dated, lower edge, left

Red Beard is distinguished from *Black Beard* by the
color ink in which it was printed.

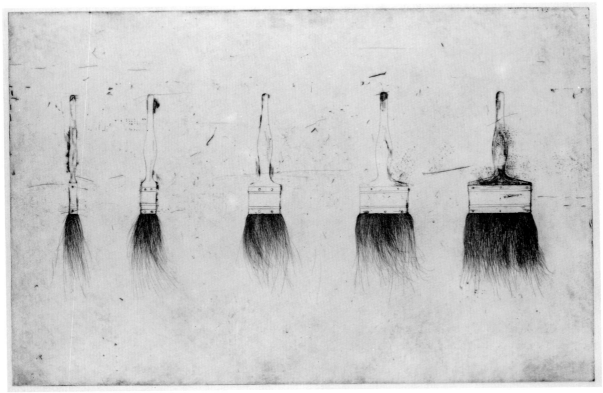

Five Paintbrushes (first state)

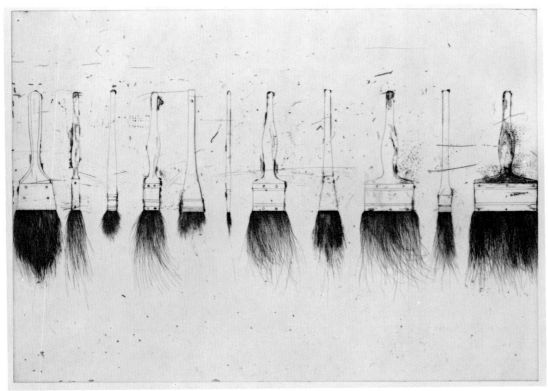

Five Paintbrushes (second state)

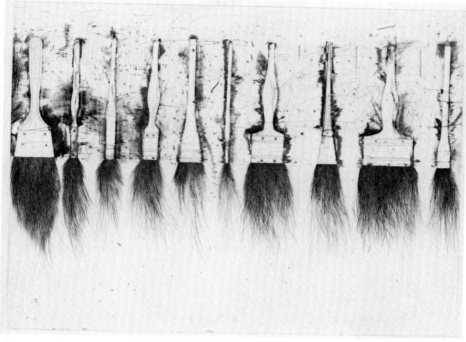

Five Paintbrushes (third state)

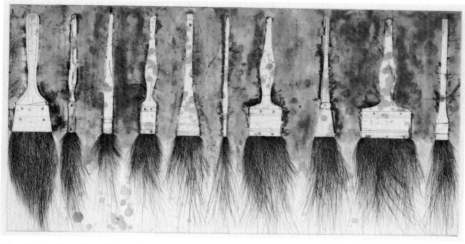

Five Paintbrushes (fourth state)

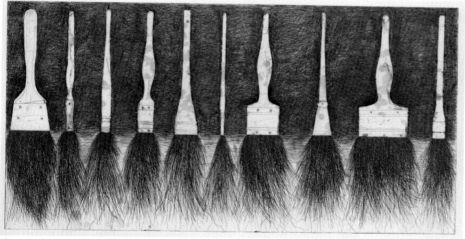

Five Paintbrushes (fifth state)

Five Paintbrushes (states one through six)

Dine made the following six prints of paintbrushes from a single plate. The first edition pulled from this plate had five brushes evenly spaced across the center of the print. For the second state edition, six brushes were added and 3¾ inches were cut from the right edge of the plate.

For the third state, three inches were cut from the top, 4½ inches from the right side, the bristles of the brushes were made fuller by additional etching and drypoint lines, and marks were added around the handles with an electric drill sander, before the state was editioned.

For the fourth state, 1¾ inches were cut from the top, 4¾ inches from the bottom, and soft ground texture was etched into the plate to provide a grey background tone and a texture on the brush handles.

The fifth state had drypoint and etched lines added to the soft ground background. The sixth state differs from the fifth only in that the edition was pulled in black-green ink.

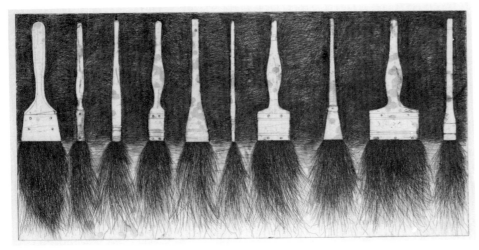

Five Paintbrushes (sixth state)

Five Paintbrushes (first state) 1972 135
Etching from one 59.7 x 90.2 cm (23½ x 35½ inch)
copper plate
Printed in black on sheet of 76.2 x 101.6 cm (30 x
40 inch) Hodgkinson Hand Made paper
Edition record: 75
 15 Artist's Proofs
Published by Petersburg Press, London; printed by
Maurice Payne
Signed and dated, below impression, left

Five Paintbrushes (second state) 1973 136
Etching from one 59.7 x 80.6 cm (23½ x 31¾ inch)
copper plate
Printed in black on sheet of 76.2 x 94.0 cm (30 x 37
inch) Copperplate Deluxe paper
Edition record: 20
 5 Artist's Proofs
Published by Petersburg Press, New York; printed by
Alan Uglow and Winston Roeth
Signed and dated, below impression, left

Five Paintbrushes (third state) 1973 137
Etching from one 52.1 x 69.2 cm (20½ x 27¼ inch)
copper plate
Printed in black on sheet of 76.2 x 90.2 cm (30 x 35½
inch) Copperplate Deluxe paper
Edition record: 28
 7 Artist's Proofs
Published by Petersburg Press, New York; printed by
Alan Uglow and Winston Roeth
Signed and dated, below impression, left

Five Paintbrushes (fourth state) 1973 138
Etching from one 35.6 x 69.2 cm (14 x 27¼ inch)
copper plate
Printed in black on sheet of 76.2 x 90.2 cm (30 x 35½
inch) Copperplate Deluxe paper
Edition record: 15
 3 Artist's Proofs
Published by Petersburg Press, New York; printed by
Alan Uglow and Winston Roeth
Signed and dated, lower edge, left

Five Paintbrushes (fifth state) 1973 139
Etching from one 35.6 x 69.2 cm (14 x 27¼ inch)
copper plate
Printed in black on sheet of 76.2 x 94.0 cm (30 x 37
inch) Copperplate Deluxe paper
Edition record: 19
 4 Artist's Proofs
Published by Petersburg Press, New York; printed by
Alan Uglow and Winston Roeth
Signed and dated, below impression, center

Five Paintbrushes (sixth state) 1973 140
Etching from one 35.6 x 69.2 cm (14 x 27¼ inch)
copper plate
Printed in green-black on sheet of 69.8 x 100.3 cm
(27½ x 39½ inch) Murillo paper
Edition record: 25
 5 Artist's Proofs
Published by Petersburg Press, New York; printed by
Alan Uglow and Winston Roeth
Signed and dated, below impression, center

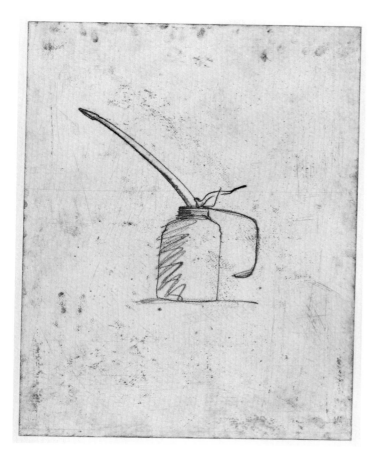

Oil Can 1973 141

Soft ground etching from one 64.7 x 49.9 cm (25½ x 19⅝ inch) copper plate

Printed in brown on sheet of 106.7 x 76.2 cm (42 x 30 inch) German Etching paper

Edition record: 75
 15 Artist's Proofs

Published by Petersburg Press, London; proofed by Hartmut Freilinghaus and editioned by Maurice Payne

Signed and dated, below impression, left

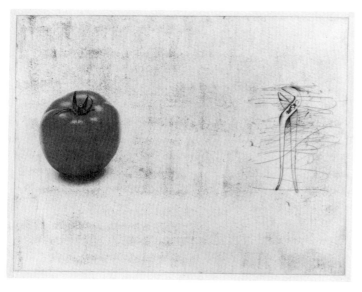

The Tomato 1973 142

Lithograph and etching: lithograph offset from four zinc plates, etching from one 60.7 x 74.9 cm (23⅞ x 29½ inch) copper plate

Lithograph printed four in colors, etching printed in brown on sheet of 76.2 x 106.7 cm (30 x 42 inch) German Etching paper

Edition record: 75
 15 Artist's Proofs

Published by Petersburg Press, London; printed by Maurice Payne

Signed and dated, below impression, left

The Tomato was a color offset lithographic reproduction taken from a magazine photograph. The four color offset was printed first and then the etching plate, with the textured background and drawing of the wrench, was dropped over it.

Bolt Cutters (first state) 1972 143

Etching from one 60.3 x 61.6 cm (23¾ x 24¼ inch) copper plate

Printed in black on sheet of 101.6 x 76.2 cm (40 x 30 inch) Hodgkinson Mould Made paper

Edition record: 75
 15 Artist's Proofs

Published by Petersburg Press, London; proofed by Hartmut Freilinghaus and printed by Maurice Payne

Signed and dated, below impression, left

Bolt Cutters (second state) 1973 144

Etching from one 61.6 x 60.3 cm (24¼ x 23¾ inch) plate, the same plate as *Bolt Cutters (first state)* rotated with aquatint and etching lines added

Printed in black on sheet of 106.7 x 76.2 cm (42 x 30 inch) Hand Made White-Wove paper

Edition record: 45
 11 Artist's Proofs

Published by Petersburg Press, New York; printed by Alan Uglow and Winston Roeth

Signed and dated, lower edge, left

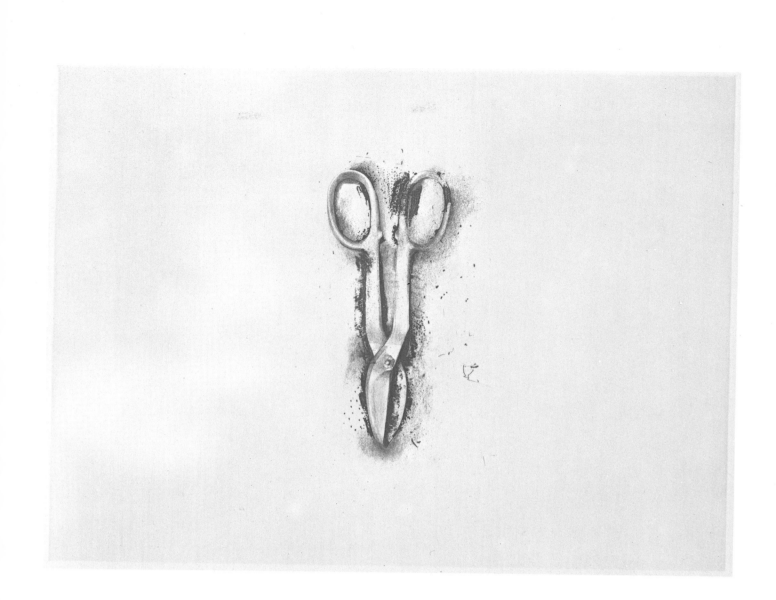

Tinsnip 1973 145

Etching and lithograph: etching from one 45.4 x 59.7
cm (17⅞ x 23½ inch) copper plate, lithograph from one
zinc plate

Etching printed in burnt umber, lithograph in dark
brown, both on sheet of 55.9 x 76.2 cm (22 x 30
inch) Arches Cover White paper

Edition record: 34

 10 Artist's Proofs

Published by Petersburg Press, New York; printed by
William Law, Alan Uglow, and Winston Roeth
Signed and dated, below impression, left

Tinsnip is a combination lithograph and etching. The
image of the tool was first drawn with a lithographic
crayon and printed from a zinc lithographic plate. A
second intaglio copper plate was used for the marks
around the tinsnips. Dine removed hard ground from the
copper with an etching needle and electric drill with
carborundum wheel, and the plate was etched in acid.
The lithograph was printed first in dull brown ink, then
the copper plate was printed in a rich, warmer brown ink
over the lithograph, in perfect register. The tan
background on the paper resulted from the plate film of
the copper plate etching.

Big Red Wrench in a Landscape 1973 146
Lithograph from five aluminum plates
Printed in blue, green, red, and black on sheet of 76.2 x
55.9 cm (30 x 22 inch) Crisbrook Waterleaf paper
Edition record: 120
　　　　　　　30 Artist's Proofs
Published by Petersburg Press, New York and Ulstein
Propylean Verlag; printed by William Law
Signed and dated, upper edge, left

The *Big Red Wrench in a Landscape* was printed in
color from five aluminum lithograph plates.
In *The Wrench in Nature*, three of the *Big Red Wrench
in a Landscape* plates were printed in color, and two
were left out—the blue sky and the drawing of the pipe
wrench. In place of the pipe wrench lithograph, Dine
drew the same tool on an etching plate and printed the
etching over the three background plates.
The etching plate in *The Wrench in Nature* was reused
and expanded three years later by Dine to make three
additional prints: *Dartmouth Still Life, Pink Chinese
Scissors*, and *Piranesi's 24 Colored Marks*, catalogue
numbers 209, 210, 211.

The Wrench in Nature 1973 147
Etching and lithograph: etching from one copper plate,
lithograph from four aluminum plates
Etching printed in black, lithograph in blue, green, black
and brown on sheet of 76.2 x 55.9 cm (30 x 22 inch)
Arches Buff paper
Edition record: 40
　　　　　　　10 Artist's Proofs
Published by Petersburg Press, New York; etching printed
by William Law, lithograph printed by Alan Uglow and
Winston Roeth
Signed and dated, upper edge, left

Braid (first state)

Braid (second state)

Braid (first state) 1972 148
Etching from one 88.9 x 61.0 cm (35 x 24 inch)
copper plate
Printed in black on sheet of 106.7 x 76.2 cm (42 x 30
inch) German Etching paper
Edition record: 46
 3 Artist's Proofs
Published by Petersburg Press, London; printed by
Maurice Payne
Signed and dated, below impression, left

Braid (second state) 1973 149
Etching from one 83.8 x 40.6 cm (33 x 16 inch) copper
plate, the same plate as *Braid (first state)*, plate size
reduced
Printed in brown on sheet of 96.5 x 63.5 cm (38 x 25
inch) Nideggen German Buff paper
Edition record: 50
 14 Artist's Proofs
Published by Petersburg Press, New York; printed by
Alan Uglow and Winston Roeth
Signed and dated, below impression, left

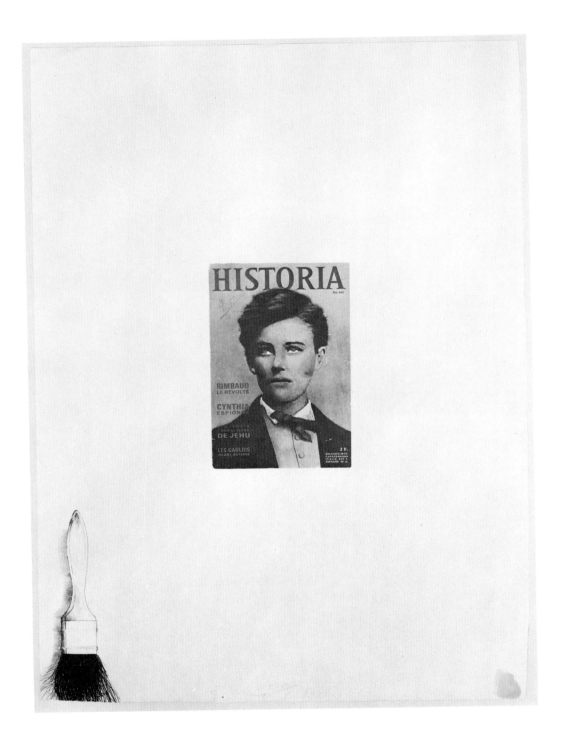

Historia 1971

150

Screen print, lithograph, and etching
Printed on sheet of 76.2 x 55.9 cm (30 x 22 inch)
Crisbrook Waterleaf paper with hand painting in
water color by the artist after editioning
Edition record: 80
 15 Artist's Proofs
Published by Petersburg Press, London; screen printed by
Christopher Betambeau, lithograph printed by Ernie
Donagh, and etching printed by Maurice Payne
Signed and dated, lower edge, center

At a Paris bookstall in 1970, Dine bought a copy of
Historia magazine that had a portrait of Rimbaud on
the front cover. At that time, he began reading
Rimbaud and the portrait was to become the focus of a
series of prints. The first, *Historia*, has a four color screen
print reproduction of the magazine cover in the center of
the print. At the bottom left hand corner, there is a
crayon drawn brush printed from a lithograph stone with
brush bristles printed from a shaped etching plate.

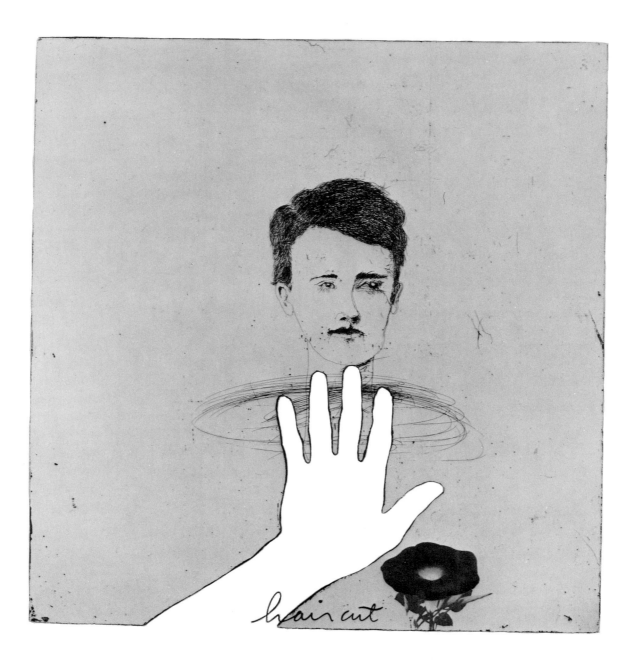

Blue Haircut 1972 151

Etching on shaped 54.0 x 50.2 cm (21¼ x 19¾ inch) copper plate, with additions in offset lithography and title in block type

Printed in color on sheet of 88.9 x 71.1 cm (35 x 28 inch) J. Green Mould Made paper

Edition record: 75

15 Artist's Proofs

Published by Petersburg Press, London; printed by Maurice Payne

Signed and dated, below impression, left

Brown Haircut 1972 152
Etching from shaped 54.0 x 50.2 cm (21¼ x 19¾ inch)
copper plate, with additions in offset lithography and
title in block type
Printed in brown on sheet of 88.9 x 71.1 cm (35 x 28
inch) J. Green Mould Made paper
Edition record: 75
 15 Artist's Proofs
Published by Petersburg Press, London; printed by
Maurice Payne
Signed and dated

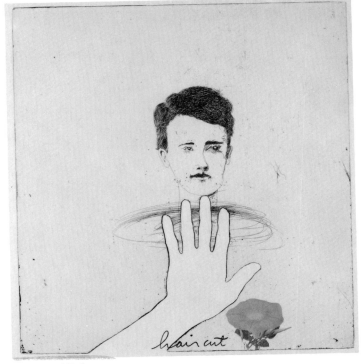

Brown Haircut

All of the prints of the Rimbaud series, except
Historia, are editioned from the same plate. The
only difference between *Blue Haircut* and *Brown
Haircut* is the color of the ink, blue and brown. In both
prints the morning glory was offset in four colors
before the etching plate was printed. The shape of the
hand was cut from the plate, making an embossment
on the surface of the print.
In the succeeding prints, *Rimbaud, Cool Impudence
on His Part* through *Rimbaud, Dead at Marseilles*,
Dine cut the plate down and added more etched lines
after each editioning. In the final two prints of the
Rimbaud series, the eyes are drilled out of the plate,
raising the white paper in relief.

**Rimbaud, Cool Impudence on
His Part** 1973 153
Etching from one 29.5 x 45.4 cm (11⅝ x 17⅝ inch)
copper plate
Printed in black on sheet of 66.0 x 50.8 cm (26 x 20
inch) Auvergne Hand Made paper
Edition record: 45
 8 Artist's Proofs
Published by Petersburg Press, New York; printed by
Alan Uglow and Winston Roeth
Signed and dated, across lower edge

Rimbaud, Cool Impudence on His Part

Rimbaud, Alchemy on Japanese Paper 1973 154
Etching from one 18.4 x 14.6 cm (7¼ x 5¾ inch)
copper plate
Printed in black on sheet of 50.8 x 40.6 cm (20 x 16
inch) Japanese Chiri paper
Edition record: 45
 6 Artist's Proofs
Published by Petersburg Press, New York; printed by
Alan Uglow and Winston Roeth
Signed and dated, lower edge, center

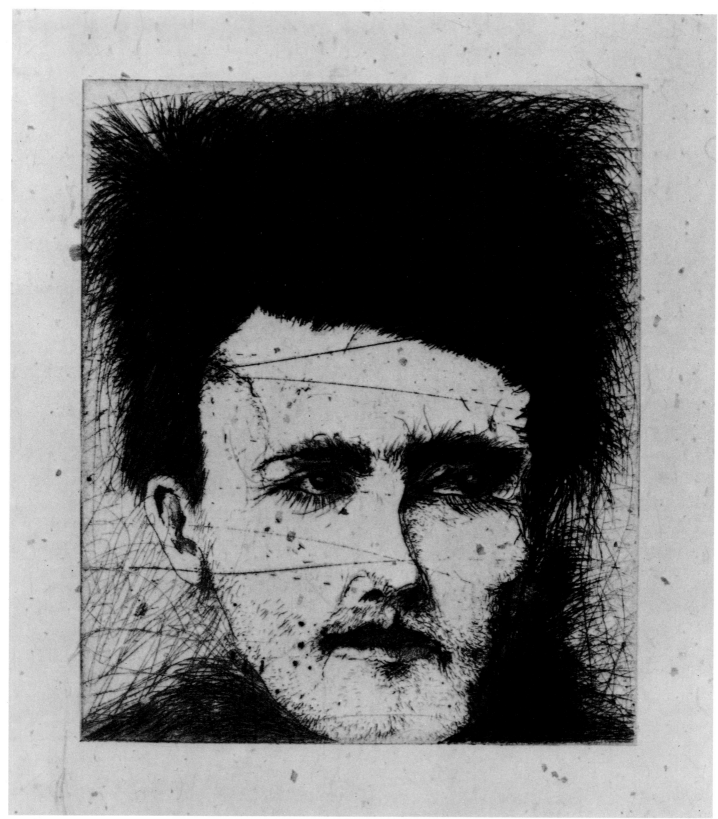

Rimbaud Alchemy, on Japanese Paper (actual size)

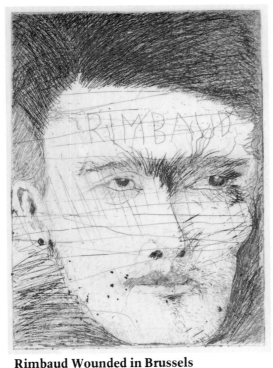

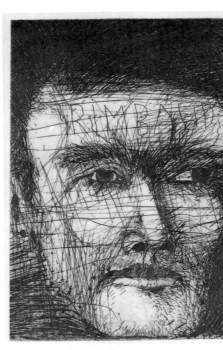

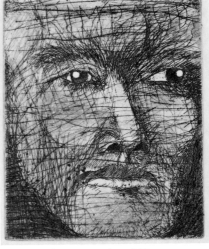

Rimbaud at Harar in 1883

Rimbaud, the Coffee Exporter

Rimbaud Wounded in Brussels

Rimbaud Wounded in Brussels 1973 155
Etching from one 14.6 x 10.8 cm (5¾ x 4¼ inch)
copper plate
Printed in blue on sheet of 76.2 x 55.9 cm (30 x 22
inch) Arches White paper
Edition record: 30
 7 Artist's Proofs
Published by Petersburg Press, New York; printed by
Alan Uglow and Winston Roeth
Signed and dated, lower edge, center

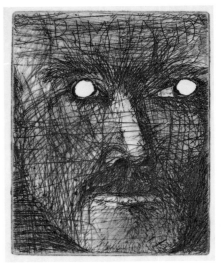

Rimbaud, Dead at Marseilles

Rimbaud, the Coffee Exporter 1973 156
Etching from one 14.0 x 9.2 cm (5½ x 3⅝ inch)
copper plate
Printed in brown on sheet of 66.0 x 50.8 cm (26 x 20
inch) Hodgkinson Hand Made paper
Edition record: 25
 10 Artist's Proofs
Published by Petersburg Press, New York; printed by
Alan Uglow and Winston Roeth
Signed and dated, lower edge, center

Published by Petersburg Press, New York; printed by
Alan Uglow and Winston Roeth
Signed and dated, lower edge, center

Rimbaud, Dead at Marseilles 1973 158
Etching from one 10.5 x 8.3 cm (4 x 3¼ inch) copper
plate
Printed in black on sheet of 45.7 x 35.6 cm (18 x 14
inch) Hodgkinson Hand Made paper
Edition record: 20
 5 Artist's Proofs
Published by Petersburg Press, New York; printed by
Alan Uglow and Winston Roeth
Signed and dated, across lower edge

Rimbaud at Harar in 1883 1973 157
Etching from one 10.5 x 8.3 cm (4⅛ x 3¼ inch)
copper plate
Printed in black on sheet of 45.7 x 35.6 cm (18 x 14
inch) Hodgkinson Hand Made paper
Edition record: 25
 2 Artist's Proofs

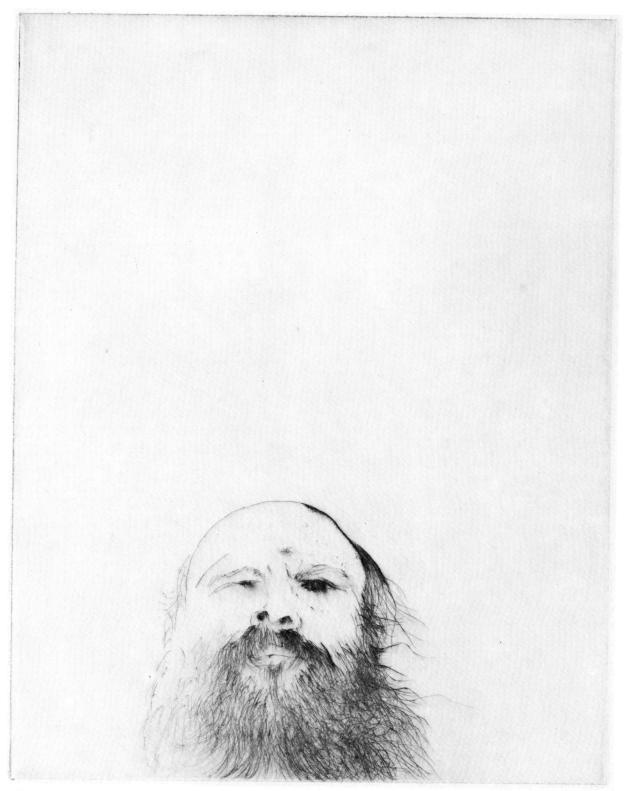

Self Portrait Head (first state)

Self Portrait Head (first state) 1972 159

Drypoint from one 33.0 x 25.4 cm (13 x 10 inch)
copper plate

Printed in brown on sheet of 76.2 x 55.9 cm (30 x 22
inch) Crisbrook Waterleaf paper

Edition record: 10
 4 Artist's Proofs

Published by Petersburg Press, London; printed by
Maurice Payne

Signed and dated, lower edge, center

Self Portrait Head (second state) 1973 160

Drypoint from one 30.5 x 22.9 cm (12 x 9 inch) copper
plate, the same plate as *Self Portrait Head (first
state)*, plate size reduced

Printed in black on sheet of 66.0 x 50.8 cm (26 x 20
inch) Apta paper

Edition record: 10
 6 Artist's Proofs

Published by Petersburg Press, New York; printed by
Alan Uglow and Winston Roeth

Signed and dated, lower edge, center

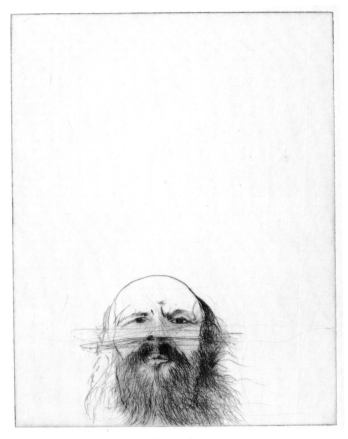

Self Portrait Head (second state)

Self Portrait Head (third state) 1973 161

Drypoint with aquatint from one 30.5 x 22.9 cm
(12 x 9 inch) copper plate, the same plate as *Self
Portrait Head (second state)* with aquatint added

Printed in black on sheet of 66.0 x 50.8 cm (26 x 20
inch) Vélin Arches Blanc paper

Edition record: 15
 4 Artist's Proofs

Published by Petersburg Press, New York; printed by
Alan Uglow and Winston Roeth

Signed and dated, across lower edge

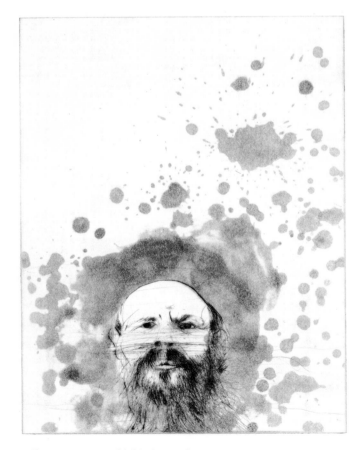

Self Portrait Head (third state)

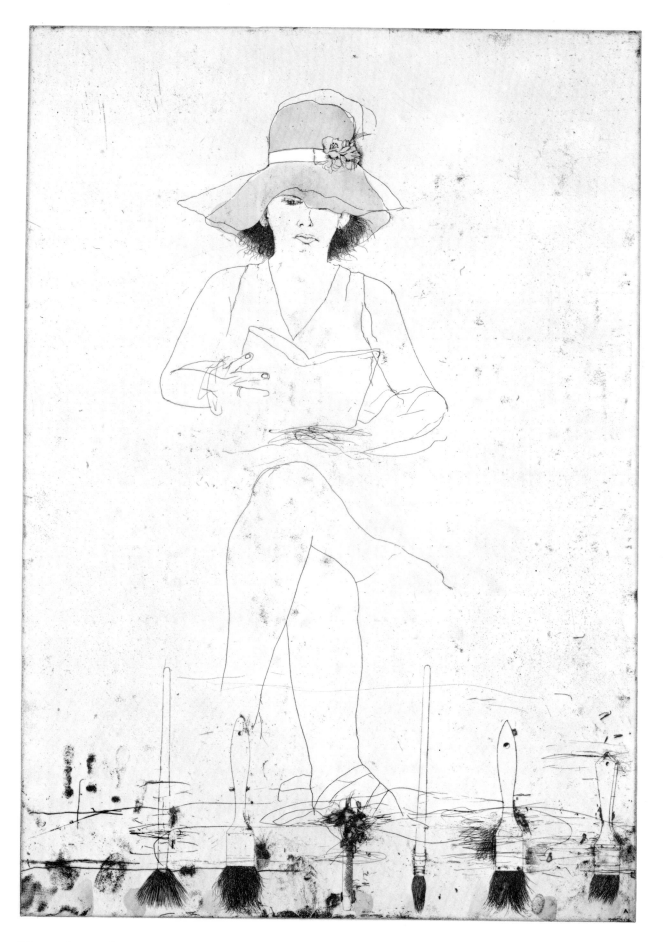

Watercolor Marks

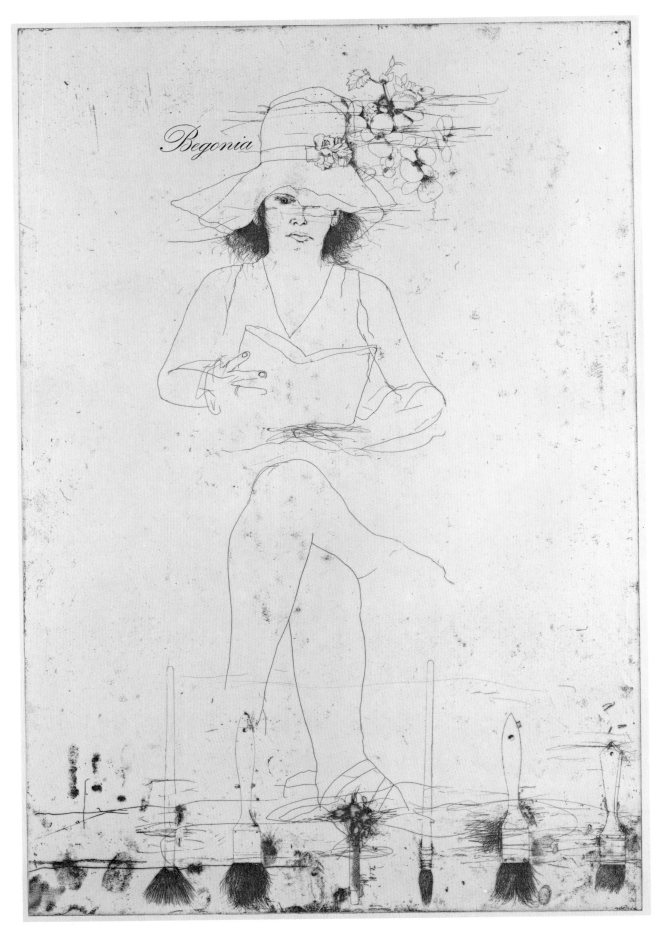

Begonia

Nancy Reading

Heads of Nancy

Nancy Reading 1973 162

Etching from one 91.4 x 61.0 cm (36 x 24 inch)
copper plate

Printed in black on sheet of 111.8 x 85.1 cm (44 x 33½
inch) American Etching paper

Edition record: 60

 15 Artist's Proofs

Published by Petersburg Press, New York; printed by
Alan Uglow and Winston Roeth

Signed and dated, below impression, right

Watercolor Marks 1973 163

Etching from one 91.4 x 61.0 cm (36 x 24 inch) copper
plate, the same plate as *Nancy Reading*, reworked

Printed in black on sheet of 111.8 x 85.1 cm (44 x 33½
inch) American Etching paper with hand painting
in watercolor by the artist after editioning

Edition record: 55

 10 Artist's Proofs

Published by Petersburg Press, New York; printed by
Alan Uglow and Winston Roeth

Signed and dated, lower edge, center

Begonia 1974 164

Etching from one 91.4 x 61.0 cm (36 x 24 inch) copper
plate, the same plate as *Watercolor Marks*, reworked
with title added in block type after editioning

Printed in black on sheet of 111.8 x 85.1 cm (44 x 33½
inch) American Etching paper

Edition record: 55

 10 Artist's Proofs

Published by Petersburg Press, New York; printed by
Alan Uglow and Winston Roeth

Signed and dated, lower edge, center

Heads of Nancy 1973 165

Etching from one 66.0 x 50.8 cm (26 x 20 inch)
copper plate

Printed in black on sheet of 76.2 x 55.9 cm (30 x 22
inch) German Etching paper

Edition record: 10

 5 Artist's Proofs

Published by Petersburg Press, New York; printed by
Alan Uglow and Winston Roeth

Signed and dated, below impression, left

In 1971 Dine did a quick sketch of his wife, Nancy, on
a copper plate, but never finished the print. The plate
spent two years on the floor of his studio accumulating
numerous scratches and footprints that removed some
of the hard ground. In 1973 Dine resurrected the plate,
had it bitten in acid, and finally editioned.

Wall Chart I 1974 166

Lithographs from four stones and three zinc plates

Printed in forty-eight colors on sheet of 121.9 x 88.9 cm
(48 x 35 inch) Rives paper

Edition record: 75

 15 Artist's Proofs

Published by Petersburg Press, London; printed by Jack
Lemon at Landfall Press, Chicago and Ernie Donagh at
Petersburg Press, London

Signed and dated, lower edge, left

Wall Chart II 1974 167

Lithographs from four stones and four zinc plates

Printed in thirty-six colors on sheet of 121.9 x 88.9 cm
(48 x 35 inch) Rives paper

Edition record: 75

 15 Artist's Proofs

Published by Petersburg Press, London; printed by Jack
Lemon at Landfall Press, Chicago

Signed and dated, lower edge, left

Wall Chart III 1974 168
Lithograph from four stones
Printed in black and white on sheet of 121.9 x
88.9 cm (48 x 35 inch) Rives paper
Edition record: 14
 4 Artist's Proofs
Published by Petersburg Press, London; printed by Jack
Lemon at Landfall Press, Chicago
Signed and dated, lower edge, left

Wall Chart IV 1974 169
Lithograph from four stones
Printed in three colors on sheet of 121.9 x 88.9 cm (48 x
35 inch) Rives paper
Edition record: 14
 4 Artist's Proofs
Published by Petersburg Press, London; printed by Jack
Lemon at Landfall Press, Chicago
Signed and dated, lower edge, left

Wall Chart I through *Wall Chart IV* were based on a
tile floor Dine installed in a bathroom in his house in
Putney, Vermont the previous summer. On the prints
that were thirty-six to forty-eight colors, many colors
were printed from a single stone by using small rollers
and only inking a small section a particular color.

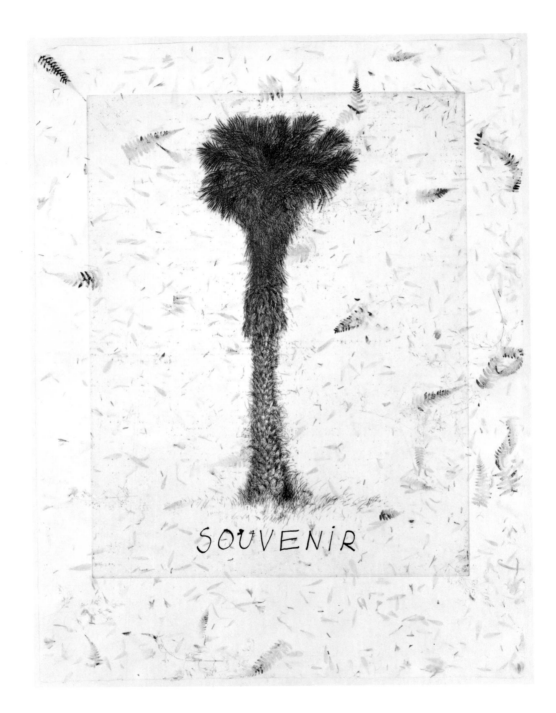

Souvenir 1974 170

Etching from one 60.0 x 45.1 cm (23⅝ x 17¾ inch)
copper plate

Printed in black on sheet of 76.2 x 55.9 cm (30 x 22
inch) Apta Blanc Fleuris Hand Made paper

Edition record: 75
 20 Artist's Proofs

Published by Petersburg Press, New York; printed by
Alan Uglow and Winston Roeth

Signed and dated

Lithographs of the Sculpture:
The Plant Becomes a Fan 1974 171-175

Suite of five lithographs, each from one aluminum plate

Printed in black on sheet of 91.4 x 61.0 cm (36 x 24 inch) Natsume 4007 paper, silkscreened with varnish after editioning

Edition record: 80
 16 Artist's Proofs

Published by Petersburg Press, New York; printed at Graphicstudio, University of South Florida, Tampa

Signed and dated, lower edge, right

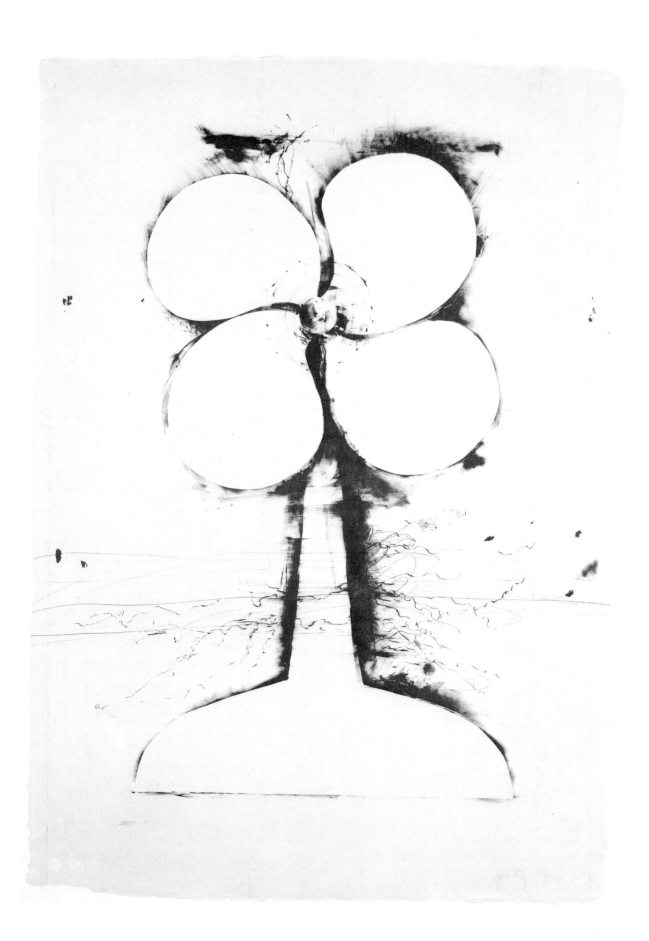

**Self Portrait in a Ski Hat
(in color) first state** 1974 176

Etching from one 29.8 x 32.4 cm (11¾ x 12¾ inch)
copper plate
Printed in black on sheet of 66.0 x 50.8 cm (26 x 20 inch)
Apta 501 paper, hand painted with oil paint in red,
yellow, and blue by the artist after editioning
Edition record: 20
 7 Artist's Proofs
Published by Petersburg Press, New York; printed by
Alan Uglow and Winston Roeth
Signed and dated, below impression, center

**Self Portrait in a Ski Hat
(surrounded by tulips) second state** 1974 177

Etching from one 24.6 x 31.4 cm (9¾ x 12⅜ inch)
copper plate
Printed in black on sheet of 76.2 x 55.9 cm (30 x 22
inch) Copperplate paper
Edition record: 25
 8 Artist's Proofs
Published by Petersburg Press, New York; printed by
Alan Uglow and Winston Roeth
Signed and dated, below impression, center

**Self Portrait in a Ski Hat
(tulips) third state** 1974 178

Etching from one 21.9 x 28.9 cm (8⅝ x 11⅜ inch)
copper plate
Printed in black on sheet of 66.0 x 50.8 cm (26 x 20
inch) Apta 501 paper
Edition record: 30
 7 Artist's Proofs
Published by Petersburg Press, New York; printed by
Alan Uglow and Winston Roeth
Signed and dated, below impression, center

**Self Portrait in a Ski Hat
(obliterated by tulips) fourth state** 1974 179
Etching from one 20.6 x 28.9 cm (8⅛ x 11⅜ inch)
copper plate
Printed in black on sheet of 66.0 x 50.8 cm (26 x 20
inch) Murillo paper
Edition record: 40
 9 Artist's Proofs
Published by Petersburg Press, New York; printed by
Alan Uglow and Winston Roeth
Signed and dated, below impression, center

As in other Dine prints, these four self portraits
were taken from the same plate. Erasures on the
reworked plates were accomplished with an
oscillating sander.

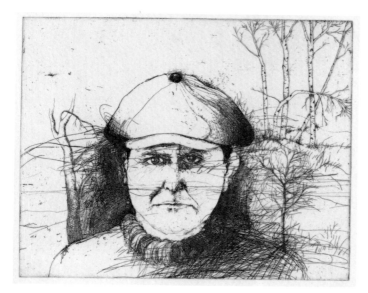

**Self Portrait in a Flat Cap
(winter) first state** 1974 180
Etching from one 27.0 x 33.0 cm (10⅝ x 13 inch)
copper plate
Printed in black on sheet of 76.2 x 55.9 cm (30 x 22
inch) Hand Made Cream paper
Edition record: 30
 11 Artist's Proofs
Published by Petersburg Press, New York; printed by
Alan Uglow and Winston Roeth
Signed and dated, across lower edge

**Self Portrait in a Flat Cap
(the green cap) second state** 1974 181
Etching from one 25.7 x 31.8 cm (10⅛ x 12½ inch)
copper plate
Printed in black and green on sheet of 66.0 x 50.8 cm
(26 x 20 inch) Vélin Arches Blanc paper
Edition record: 28
 8 Artist's Proofs
Published by Petersburg Press, New York; printed by
Alan Uglow and Winston Roeth
Signed and dated, below impression, center

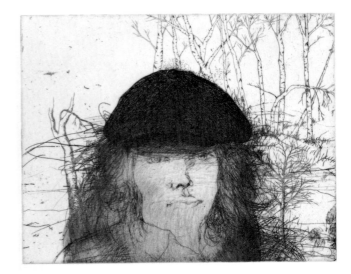

**Self Portrait in a Flat Cap
(baboon) third state** 1974 182
Etching from one 25.4 x 31.4 cm (10 x 12⅜ inch)
copper plate
Printed in black on sheet of 66.0 x 50.8 cm (26 x 20
inch) Apta 501 paper
Edition record: 35
 10 Artist's Proofs
Published by Petersburg Press, New York; printed by
Alan Uglow and Winston Roeth
Signed and dated, below impression, center

**Self Portrait in a Flat Cap
(weeds) fourth state** 1974 183
Etching from one 25.4 x 31.4 cm (10 x 12⅜ inch)
copper plate
Printed in black on sheet of 66.0 x 50.8 cm (26 x 20
inch) Apta 501 paper
Edition record: 38
 14 Artist's Proofs
Published by Petersburg Press, New York; printed by
Alan Uglow and Winston Roeth
Signed and dated, below impression, center

Self Portraits (1971)

Dartmouth Portraits

The Dartmouth Portraits are reworked plates from an earlier drypoint self portrait series done in 1971. For the second set, Dine used the same plates, the same theme and, in most cases, a similar image size and position. The 1971 *Self Portrait* plates were effaced with an oscillating sander. Shadows of the earlier image remained, over which Dine drew and etched another self portrait on each of the plates. Adjacent impressions on each page of the catalogue were pulled from the same plate.

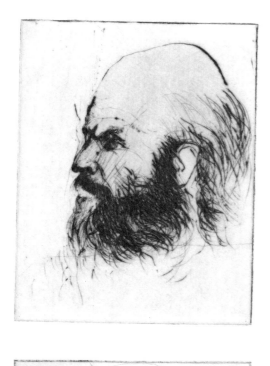

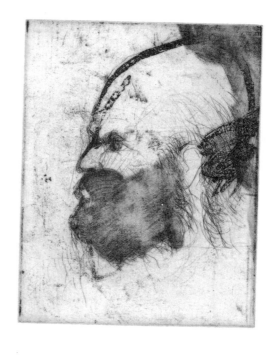

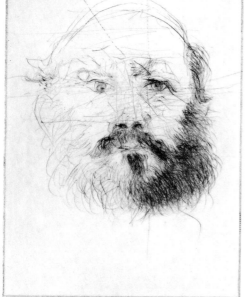

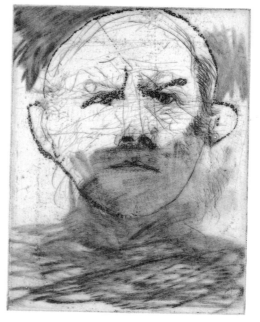

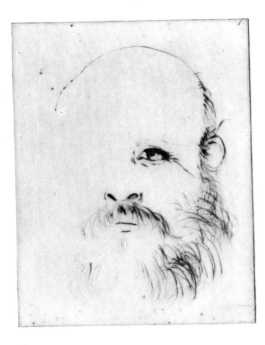
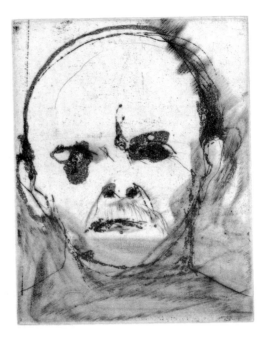
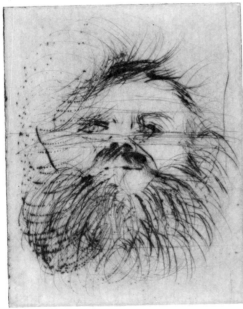
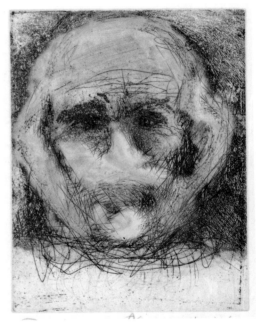
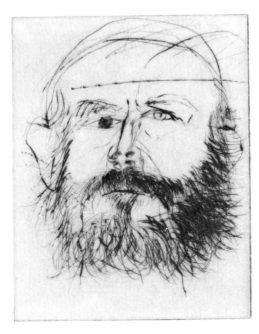
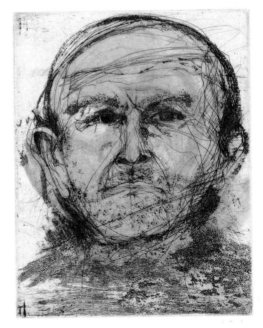

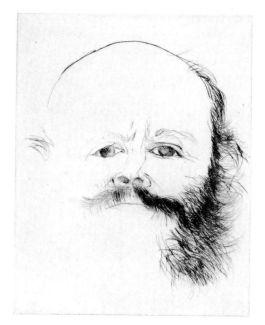
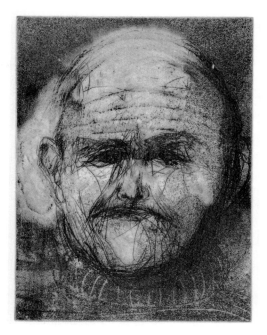
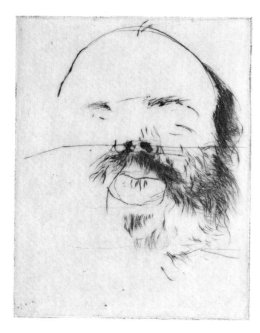
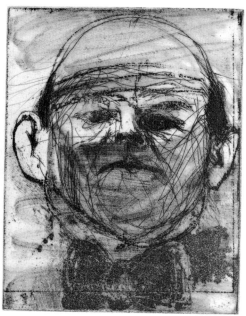
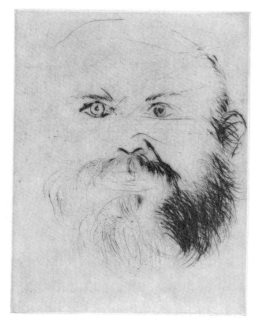
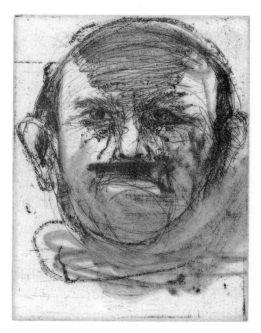

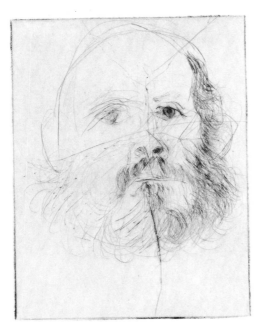

Self Portraits (1971) 47-55

Portfolio of nine drypoints, each from one 20.3 x 15.2 cm
(8 x 6 inch) copper plate

Printed in brown-black on sheet of 45.7 x 35.6 cm (18 x
14 inch) Hodgkinson Hand Made Tone-Weave paper

Edition record: 25

 5 Artist's Proofs

Published by Petersburg Press, New York; printed by
Maurice Payne

Signed and dated, below impression, center

**Self Portraits—second published state
(the Dartmouth Portraits)** 1975 184-192

A suite of nine etchings, each from one 20.3 x 15.2 cm
(8 x 6 inch) copper plate, the same plates as *Self Portraits
(1971)*, with aquatint, hard ground, and soft ground added

Printed in black on sheet of 52.0 x 39.4 cm (20½ x 15½
inch) Buff Japanese Etching paper

Edition record: 25

 7 Artist's Proofs

Published by Petersburg Press, New York; proofed by
Mitchell Friedman and
printed by Alan Uglow and Winston Roeth

Signed and dated, below impression, center

The Red Bandana 1974 193
Lithograph from one zinc plate
Printed in red on sheet of 121.9 x 89.5 (48 x 35¼
inch) J. Lemon Hand Made paper
Edition record: 50
 15 Artist's Proofs
Published by Pace Editions, New York; printed
by Alan Uglow and Winston Roeth
Signed and dated, lower edge, right

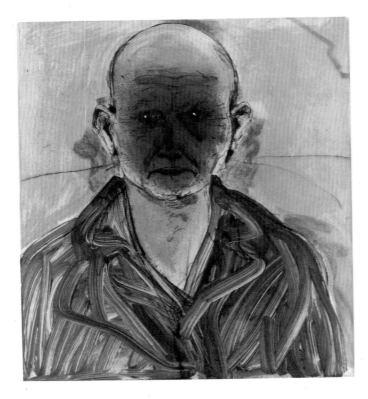

A Hand Painted Self Portrait 1975 194

Etching from one 50.8 x 45.1 cm (20 x 17¾ inch) copper plate, with monotype and additions by hand in oil paint and oil pastel

Printed in black on sheet of 104.1 x 69.9 cm (41 x 27½ inch) English Etching paper

Edition record: 6
 plus Artist's Proofs

Published by Universal Limited Art Editions, West Islip, Long Island; printed by Zigmunds Priede

Signed and dated, below impression, left

The drawing in *A Hand Painted Self Portrait* was done by using both etching and drypoint techniques. In printing the edition, Dine first brushed oil paint onto the uninked surface of the plate and the plate printed a monotype impression by running it through the press. The plate was cleaned, then inked and wiped in the traditional manner and printed over the monotype impression. With the inks still wet, Dine smeared the intaglio and monotype inks together, softening the features of the self portrait. Then the plate was inked and wiped and intaglio printed again. White chalk was then used by the artist directly on each finished print to highlight the eyeballs and the top of his head.

The *Positive Self Portrait, State 2* and *Self Portrait as a Negative* are printed from the same plate after it had been cut down.

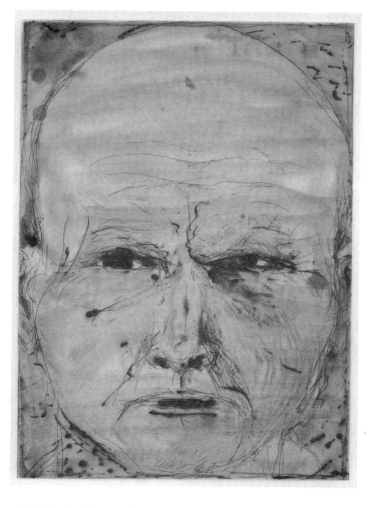

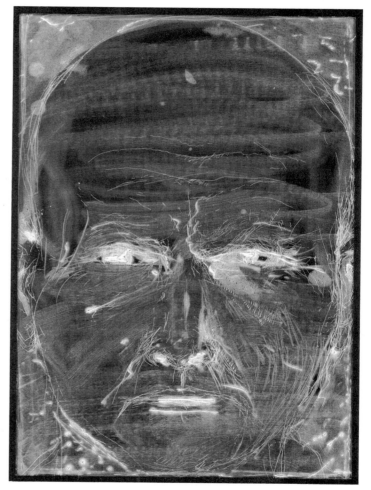

Positive Self Portrait, State 2 1975 195

Etching from one 24.8 x 17.5 cm (9¾ x 6⅞ inch)
copper plate, the same plate as *A Hand Painted Self
Portrait,* plate size reduced, reworked with drypoint
and power tool

Printed in reddish-black on sheet of 61.0 x 45.7 cm (24
x 18 inch) J. Goodman Hand Made paper

Edition record: 11

plus Artist's Proofs

Published by Universal Limited Art Editions, West
Islip, Long Island; printed by Zigmunds Priede
Signed and dated, below impression, center

Self Portrait as a Negative 1975 196

Etching from one 24.8 x 17.5 cm (9¾ x 6⅞ inch) copper
plate, the same plate as *Positive Self Portrait*

Printed in white on sheet of 66.0 x 50.8 cm (26 x 20
inch) Fabriano Black paper

Edition record: 39

plus Artist's Proofs

Published by Universal Limited Art Editions, West
Islip, Long Island; printed by Zigmunds Priede
Signed and dated, below impression, left

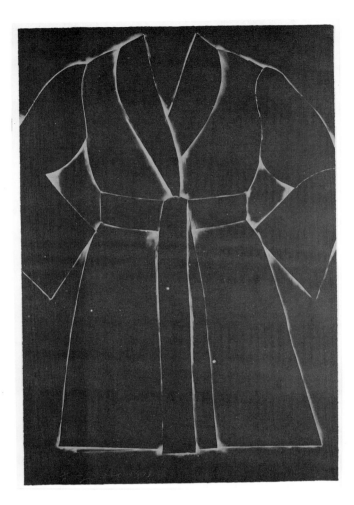

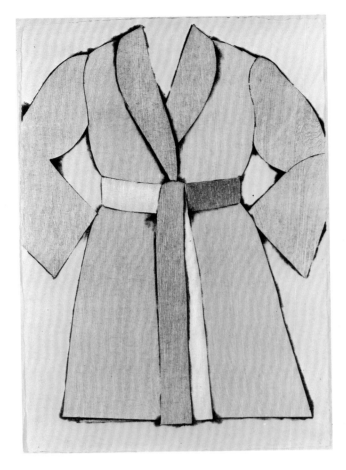

Black and White Bathrobe 1975 197

Lithograph: image from the same zinc plate as *The Woodcut Bathrobe,* background from a second zinc plate

Printed in black and white on sheet of 89.5 x 62.9 cm (35¼ x 24¾ inch) Arches White paper

Edition record: 80

13 Artist's Proofs

Published by Petersburg Press, New York; printed at Graphicstudio, University of South Florida, Tampa

Signed and dated, lower edge, left

The Woodcut Bathrobe 1975 198

Woodcut and lithograph: woodcut from plywood, lithograph from one zinc plate

Woodcut printed in twelve colors, lithograph printed in black on sheet of 91.4 x 61.0 cm (36 x 24 inch) Natsume 4007 paper

Edition record: 80

16 Artist's Proofs

Published by Petersburg Press, New York; printed at Graphicstudio, University of South Florida, Tampa

Signed and dated, lower edge, left

The Woodcut Bathrobe was begun as a single color lithograph of a bathrobe. From this print Dine traced the outline of the robe. He then cut his tracing into sections and had pieces of plywood cut to match these patterns. After each wooden section was inked a different color, the plywood robe was reassembled. A sheet of Natsume paper was relief printed by hand by rubbing with a spoon from the back. Once the entire relief impression had been pulled, the black lithograph bathrobe was printed over the woodcut.

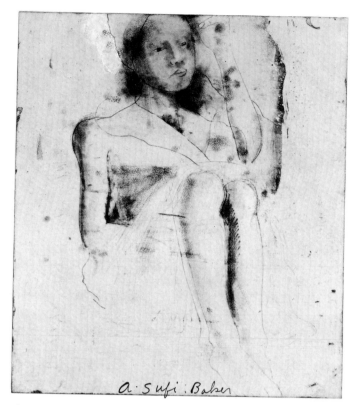

A Sufi Baker

Eight Sheets from an Undefined Novel

Etchings, from a suite of eight, each from one 61.0 x 50.8 cm (24 x 20 inch) copper plate with soft ground, titles in block print
Printed in black on sheet of 106.7 x 76.2 cm (42 x 30 inch) German Etching paper, with hand painting in water color by the artist after editioning
Published by Pyramid Arts, Ltd., Tampa; trial proofing by Mitchell Friedman, Bon-A-Tirer by Donald Saff, and editioning by Tom Kettner with the assistance of Ralph Durham
Signed and dated, below impression, left

In the *Eight Sheets from an Undefined Novel* series, Dine used scratched, unpolished roofer's copper for his plates. Large preparatory drawings of each figure were made on 40 x 30 inch hand made paper. Dine had each of the drawings photographed and reduced to 24 x 20 inches. The photographs were traced and the tracing paper then placed over the soft grounded copper plate and the tracings gone over again. The paper lifted the ground wherever pressure was applied by the drawing instrument, exposing the copper to action by the acid. Once the outline had been etched into the plate, Dine worked directly on the plate surface with drypoint, soft ground, and hard ground etching techniques through approximately ten states. After the Bon-A-Tirer impression had been pulled, the copper plates were all steel faced to prevent breakdown of the subtle soft ground textures during editioning. (See pages 18-19 for a comparison of the drawing of the *Russian Poetess* with the completed print.)

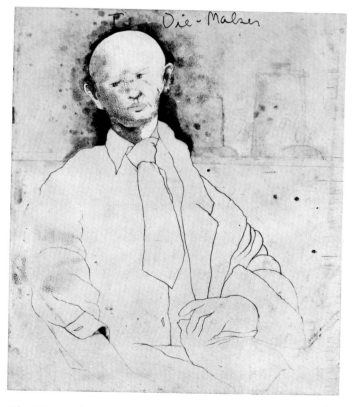

The Die-Maker

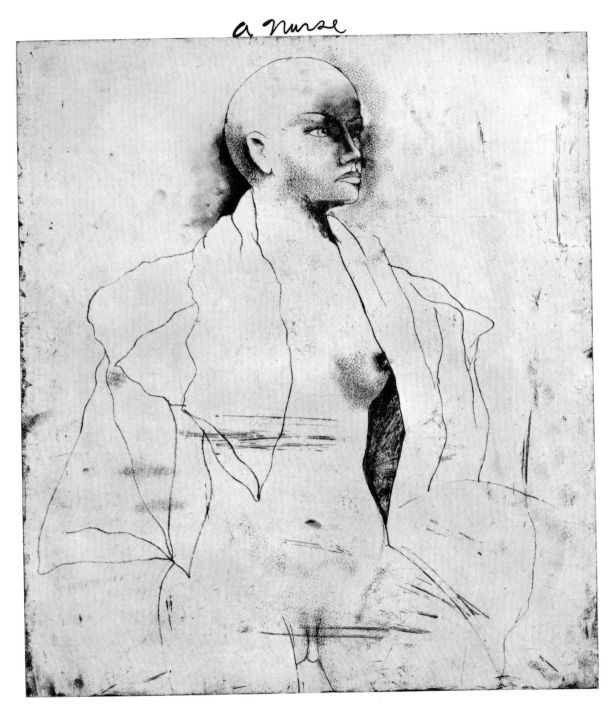

A Nurse

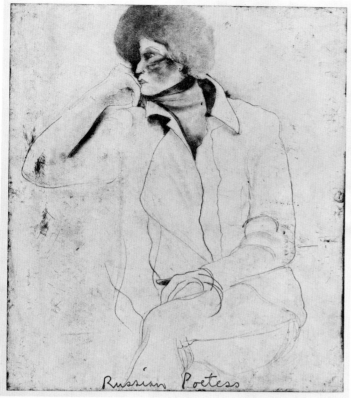

Russian Poetess

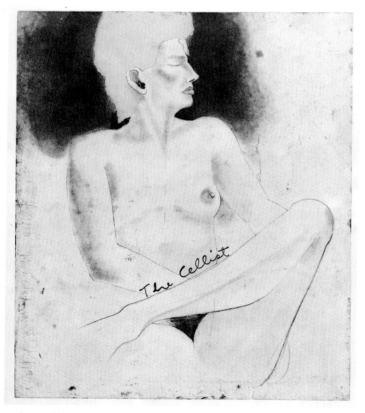

The Cellist

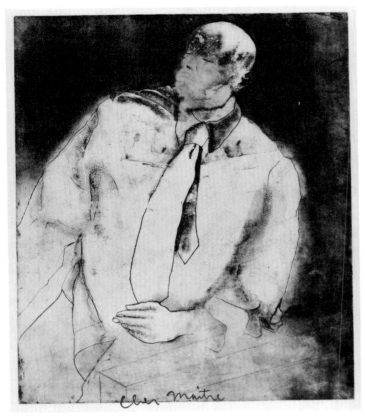

Cher Maitre

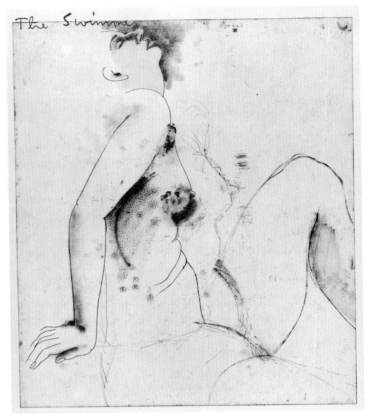

The Swimmer

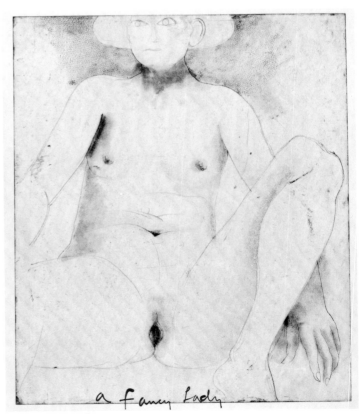

A Fancy Lady

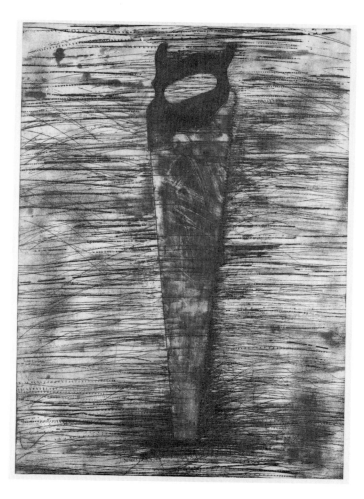

Saw 1976 207

Etching from one 82.5 x 57.2 cm (32½ x 22½ inch)
copper plate

Printed in black on sheet of 107.9 x 76.2 cm (42½ x 30
inch) Copperplate paper

Edition record: 30
 10 Printer's Proofs
 4 Artist's Proofs

Published by Pyramid Arts, Ltd., Tampa; proofed and
printed by Mitchell Friedman

Signed and dated, below impression, center

The aquatint-like tonal grey areas on the blade of the
saw were obtained by brushing ferric chloride directly
on the plate and placing the plate in the sun. The ferric
chloride etched the copper as the sun caused the
chemical to crystalize and produce the unusual
textured bite.

**Two Figures Linked by
Pre-Verbal Feelings** 1976 208

Etching with drypoint and photographically
transferred drawing from one 70.5 x 57.8 cm (27¾ x
22¾ inch) copper plate

Printed in black on sheet of Mitsumata paper overlaid
on sheet of 106.7 x 76.2 cm (42 x 30 inch) German
Etching paper, screen printing and hand coloring in red
water color by the artist after editioning

Edition record: 30
 5 Printer's Proofs
 7 Artist's Proofs

Published by Pyramid Arts, Ltd., Tampa; proofed by
Mitchell Friedman, editioned by Ralph Durham, and
screenprinted by Julio Juristo

Signed and dated, below impression, left

A large drawing that Dine had been working and
reworking for over a year was the point of departure for
this print. He had the drawing photomechanically
reproduced on an eighteen gauge copper plate and then
worked the copper directly with etching and drypoint
techniques.

Once the copper plate image was determined, the print
was editioned on Mitsumata paper mounted on
German Etching—a chine collé process. The heart was
silkscreened in opaque white ink and colored red with
water color by the artist.

Dartmouth Still Life 1974-1976

Etching from one 70.5 x 61.0 cm (27¾ x 24 inch)
copper plate
Printed in black on sheet of 106.7 x 76.2 cm (42 x 30 inch)
German Etching paper, with hand coloring in crayon by
the artist after editioning
Edition record: 30
 6 Artist's Proofs
Published by Petersburg Press, New York; proofed by
Mitchell Friedman, printed by Alan Uglow and
Winston Roeth
Signed and dated, below impression, center

209

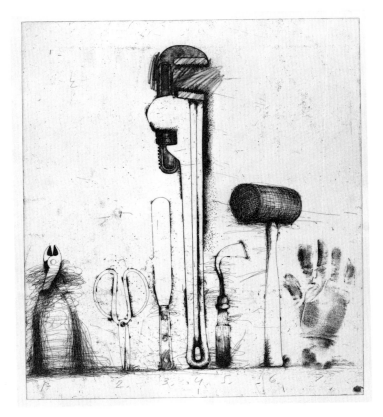

Pink Chinese Scissors 1974-1976

Etching from one 70.5 x 61.0 cm (27¾ x 24 inch)
copper plate
Printed in black on sheet of 106.7 x 76.2 cm (42 x 30
inch) French Hand Made paper, the scissors hand
colored pink in water color by the artist after
editioning
Edition record: 30
 6 Artist's Proofs
Published by Petersburg Press, New York; proofed by
Mitchell Friedman, printed by Alan Uglow and
Winston Roeth
Signed and dated, below impression, left

210

The plate in these three prints, *Dartmouth Still Life*,
Pink Chinese Scissors, and *Piranesi's 24 Colored
Marks* was successively reworked from the etching plate
used in *Wrench in Nature*, (1973, number 147). The glove
texture that first appears in *Dartmouth Still Life* was
obtained by pressing a glove into the heated hard
ground on the plate surface, thereby removing some of the
ground and exposing the copper to the action of the acid.

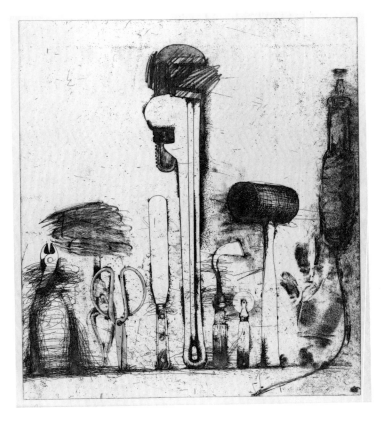

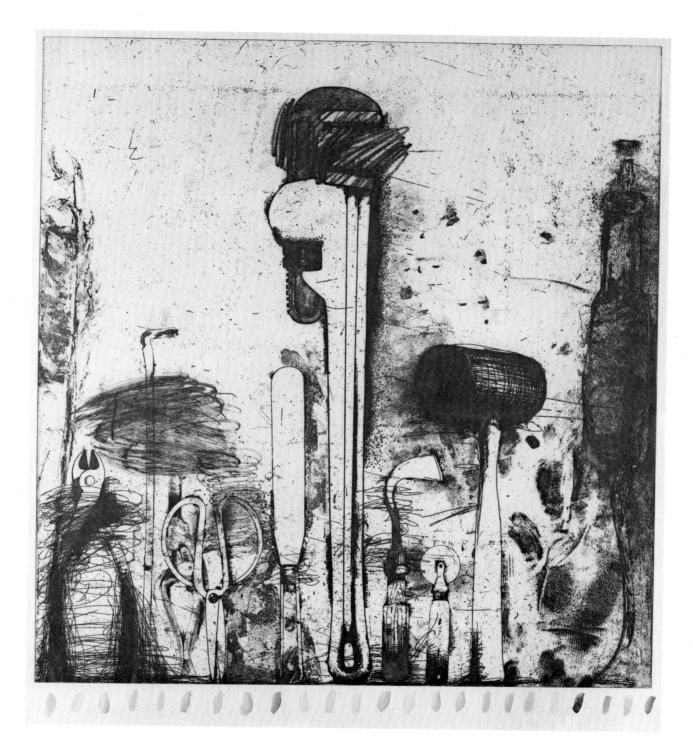

Piranesi's 24 Colored Marks 1974-1976 211
Etching from one 65.4 x 60.3 cm (25¾ x 23¾ inch)
copper plate
Printed in black on sheet of 100.3 x 70.1 cm (39½ x 27½
inch) Murillo paper, hand painting in water color by the
artist after editioning
Edition record: 30
 6 Artist's Proofs
Published by Petersburg Press, New York; proofed by
Mitchell Friedman, printed by Alan Uglow and
Winston Roeth
Signed and dated, lower edge, left

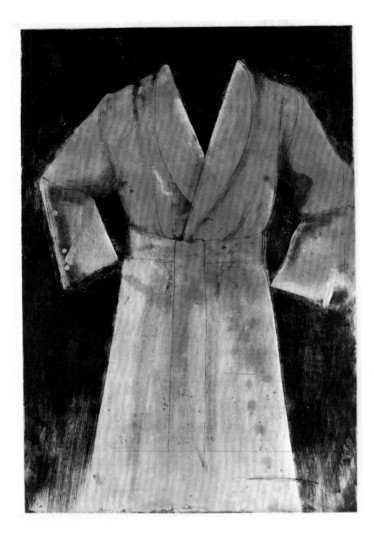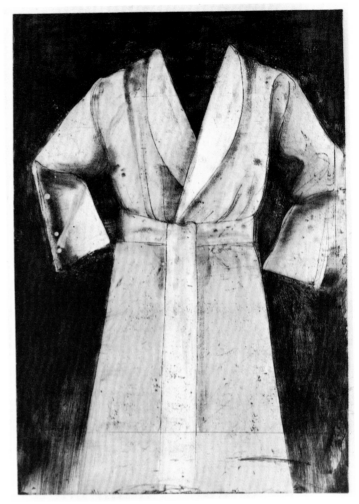

Red Etching Robe 1976 212
Etching from two 90.2 x 59.7 cm (35½ x 23½ inch)
copper plates
Printed in red and black on sheet of 108.0 x 76.2 cm
(42½ x 30 inch) Copperplate Deluxe paper
Edition record: 36
 6 Artist's Proofs
Published by Pace Editions, New York; proofed by
Mitchell Friedman, printed by Mitchell Friedman and
Winston Roeth
Signed and dated, below impression, left

**A Robe Colored with 13 Kinds
of Oil Paint** 1976 213
Etching with soft ground from one 90.2 x 59.7 cm
(35½ x 23½ inch) copper plate
Printed in fourteen colors on sheet of 108.0 x 76.2 cm
(42½ x 30 inch) Copperplate Deluxe paper
Edition record: 10
 plus Artist's Proofs
Published by Pace Editions, New York; proofed and
printed by Mitchell Friedman
Signed and dated, below impression, left

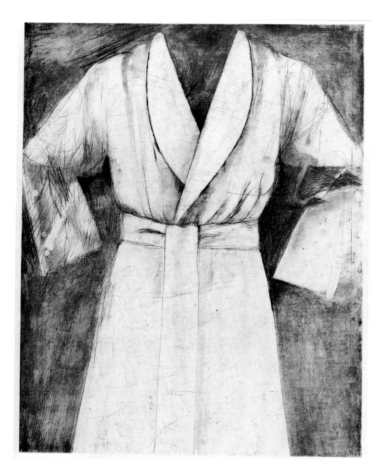

Warm Drypoint Robe 1976
Etching from one 73.7 x 55.9 cm (29 x 22 inch)
copper plate
Printed in green and black on sheet of 108.0 x 76.2 cm
(42½ x 30 inch) Copperplate Deluxe paper
Edition record: 6
 plus Artist's Proofs
Published by Pace Editions, New York; proofed and
printed by Mitchell Friedman with the assistance of
Jeremy Dine
Signed and dated, below impression, left

Red Etching Robe, A Robe with 13 Kinds of Oil Paint,
and *Warm Drypoint Robe* are all successively
reworked versions of the same plate. In *Red Etching
Robe,* a second plate with a background texture was
printed in red. For *A Robe Painted with 13 Kinds of
Oil Paint,* the color was applied to the same master
plate and printed at once, then the master was inked in
black and printed again in register. The slight deviation
from perfect register accounts for the fuzzy softness of
the print.
Warm Drypoint Robe was printed in green ink after
4½ inches had been cut from the bottom of the plate,
2 inches from the top, and 1½ inches from the left side.

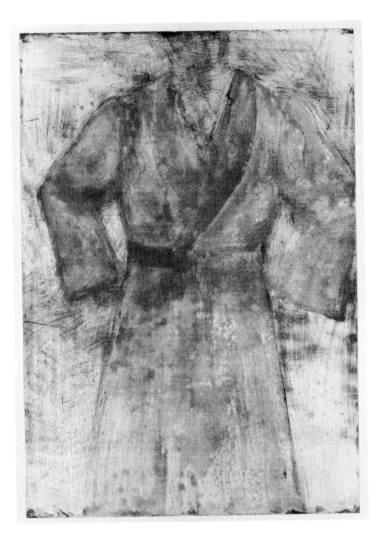

2 Robes (Ferns, Acid and Water) 1976 215
Diptych etching from two 90.2 x 59.7 cm (35½ x 23½
inch) copper plates
Printed in black on two sheets of 108.0 x 76.2 cm (42½ x
30 inch) Copperplate Deluxe paper
Edition record: 15
 5 Artist's Proofs
Published by Pace Editions, New York; proofed and
printed by Mitchell Friedman with the assistance of
Jeremy Dine
Signed and dated

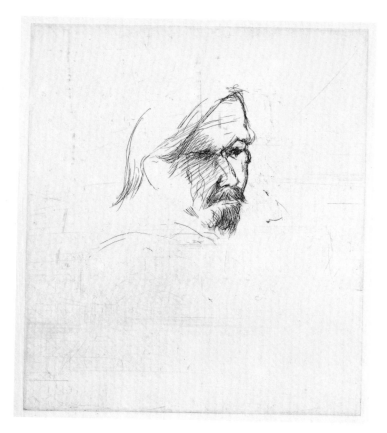

Little Sketched Head of Creeley 1976 216
Drypoint from one 18.4 x 15.2 cm (7¼ x 6 inch)
copper plate
Printed in brown on sheet 44.5 x 36.8 cm (17½ x 14½
inches)
Edition record: 10 Hors Commerce
 plus Artist's Proofs
printed by Jeremy Dine
Signed and dated

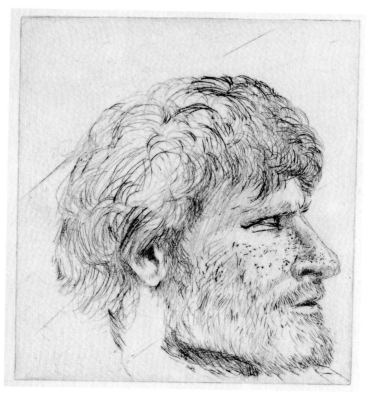

Kitaj by Dine 1976 217
Drypoint from one 13.3 x 12.1 cm (5¼ x 4¾ inch)
copper plate
Printed in brown on sheet 44.5 x 36.8 cm (17½ x 14½
inches)
Edition record: 6 Hors Commerce
 plus Artist's Proofs
proofed and printed by Mitchell Friedman with the
assistance of Jeremy Dine
Signed and dated

Paris Smiles 1976 218

Etching, drypoint, lift and soft ground from four 59.7 x 50.2 cm (23½ x 19¾ inch) copper plates with title in block print

Printed in black on sheet of 89.7 x 62.9 cm (35¼ x 24¾ inch) Arches White paper

Edition record: 45
 plus Artist's Proofs

Published and printed by Aldo Crommelynck, Paris
Signed and dated, below impression, left

Paris Smiles in Darkness 1976 219

Etching, drypoint, lift and soft ground from five 59.7 x 50.2 cm (23½ x 19¾ inch) copper plates with title in block print

Printed in four colors on sheet of 89.7 x 62.9 cm (35¼ x 24¾ inch) Arches White paper

Edition record: 45
 plus Artist's Proofs

Published and printed by Aldo Crommelynck, Paris
Signed and dated, below impression, left

Retroussage Eiffel Tower 1976 220

Etching, drypoint, lift and soft ground from five 59.7 x
50.2 cm (23½ x 19¾ inch) copper plates
Printed in black and white on sheet of 89.7 x 62.9 cm
(35¼ x 24¾ inch) Rives paper
Edition record: 45
 plus Artist's Proofs
Published and printed by Aldo Crommelynck, Paris
Signed and dated, below impression, left

Dine used a retroussage technique to obtain the dark
tones in this print. With this method the printer does
not wipe the ink completely off the surface of the plate
as in a usual intaglio print, giving the impression
overtones of a monotype.

Drypoint Eiffel Tower 1976 221

Etching, drypoint, lift and soft ground from four 59.7 x
50.2 cm (23½ x 19¾ inch) copper plates
Printed in black on sheet of 89.7 x 62.9 cm (35¼ x 24¾
inch) Arches Buff paper
Edition record: 45
 plus Artist's Proofs
Published and printed by Aldo Crommelynck, Paris
Signed and dated, below impression, left

**Dark Blue Self Portrait
with White Crayon** 1976 222

Etching from one 50.8 x 45.7 cm (20 x 18 inch)
copper plate

Printed in black on sheet of 76.2 x 55.9 cm (30 x 22 inch)
Copperplate paper with white crayon and hand painting
in watercolor by the artist after editioning

Edition record: 11
　　　　　4 Williams Proofs
　　　　　1 Printer's Proof
　　　　　3 Artist's Proofs

Published by Pace Editions; proofed by Mitchell
Friedman, printed by Mitchell Friedman and Phillip
Eagleburger
Signed and dated

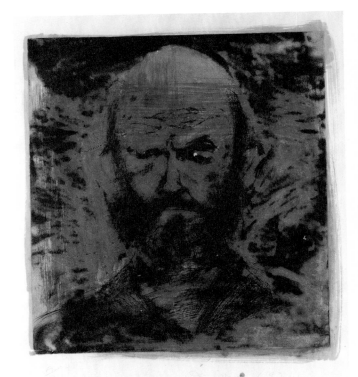

**Asian Woman, Pregnant
and Grieving** 1976 223

Etching with soft ground from one 95.3 x 64.8 cm
(37½ x 25½ inch) copper plate

Printed in black on sheet of 108.0 x 76.2 cm (42½ x
30 inch) Copperplate Deluxe paper with hand coloring
in charcoal by the artist after editioning

Edition record: 23
　　　　　8 Williams Proofs
　　　　　2 Printer's Proofs
　　　　　3 Artist's Proofs

Published by Pace Editions; proofed by Mitchell
Friedman, printed by Mitchell Friedman and Phillip
Eagleburger
Signed and dated

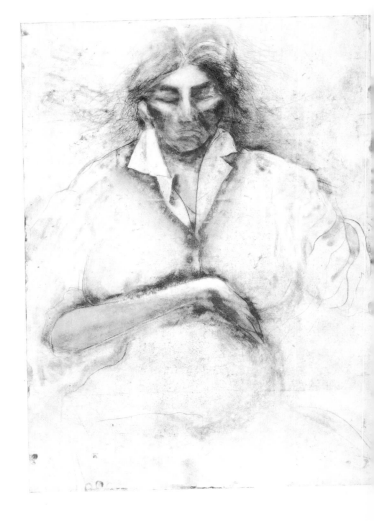

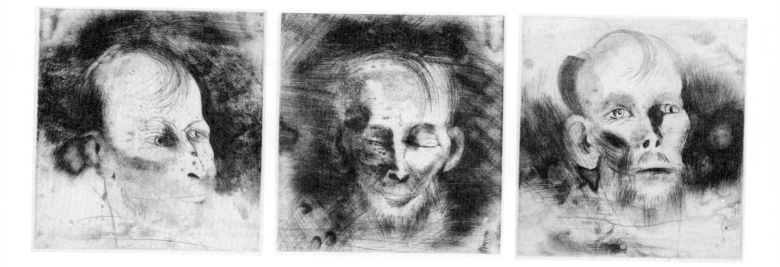

Portrait of Peter Eyre 1976 224
Triptych etching with soft ground from three 31.0 x 30.5
(13 x 12 inch) copper plates
Printed in black on three sheets of 55.9 x 38.1 cm
(22 x 15 inch) Kilmurry paper
Edition record: 21
 8 Williams Proofs
 8 Artist's Proofs
Published by Pace Editions; proofed and printed by
Mitchell Friedman
Signed and dated

Mabel

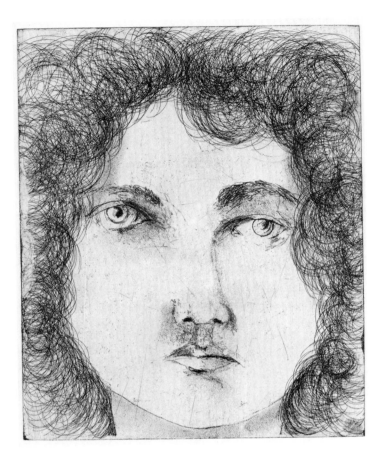

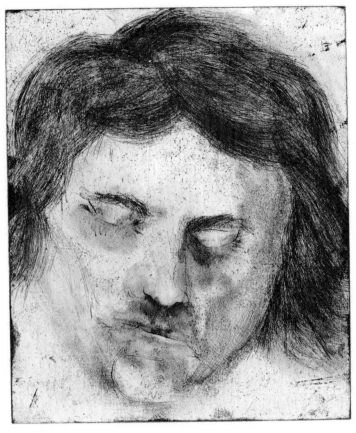

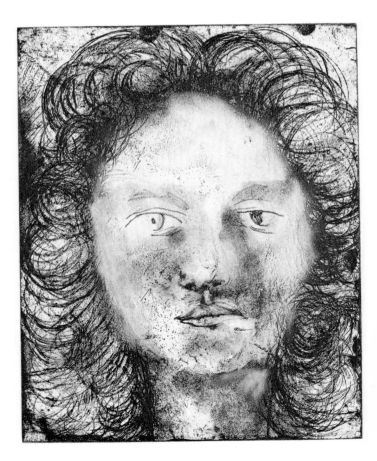

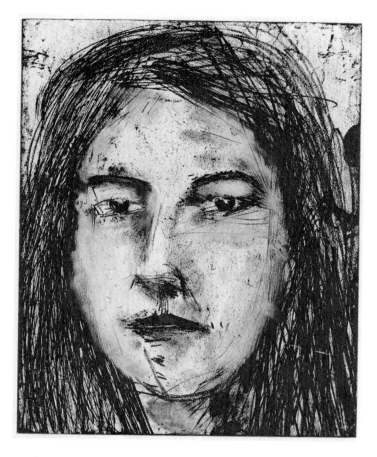

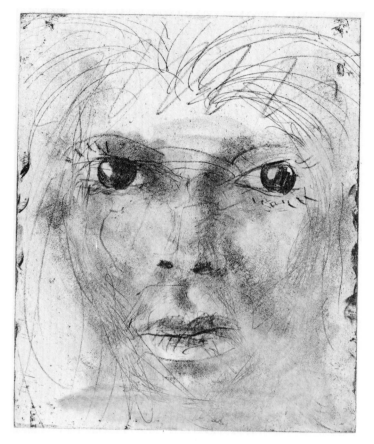

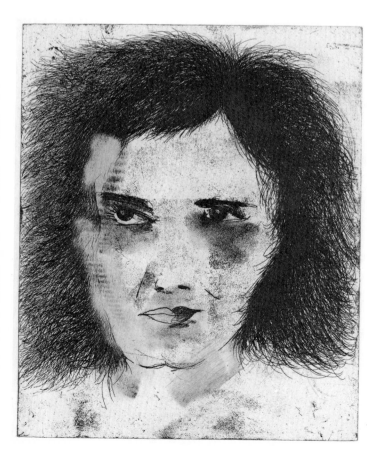

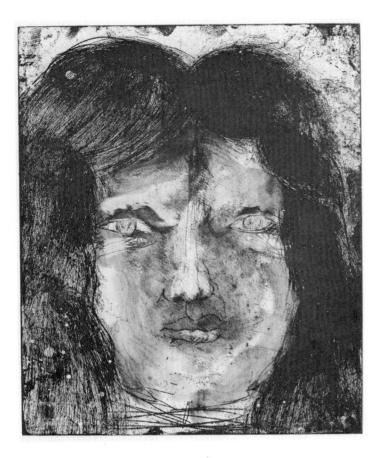

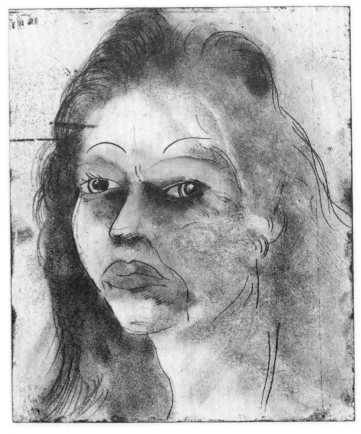

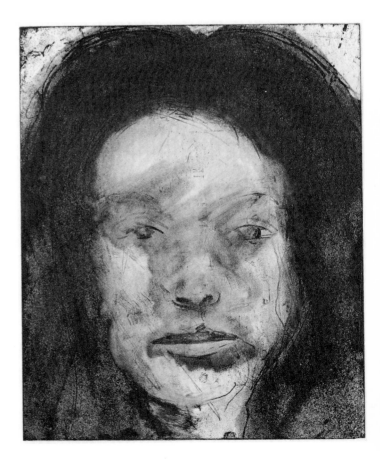

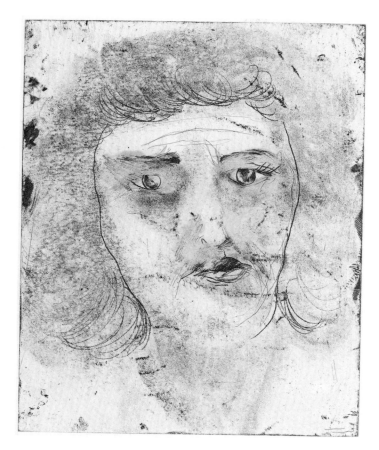

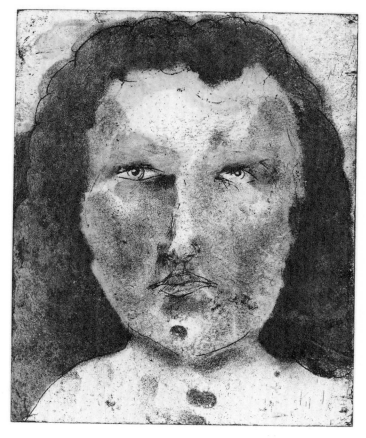

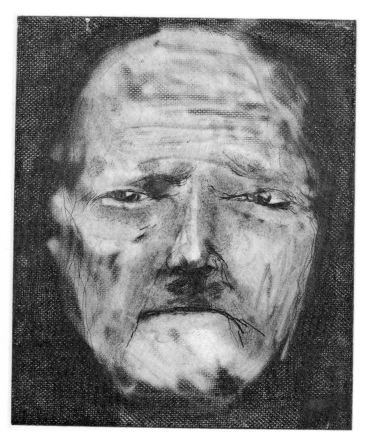

Mabel 1977 225-236

Portfolio of twelve etchings with soft ground from
twelve 23.2 x 18.4 cm (9⅛ x 7¼ inch) copper plates

Printed in black on sheets of 49.5 x 38.1 cm (19½ x 15
inch) d'Auvergne paper

Edition record: 60
 10 Artist's Proofs
 10 Hors Commerce

Published and printed by Aldo Crommelynck, Paris
Signed and dated

For this project, Jim Dine collaborated with Robert
Creeley to compose a book. Creeley contributed a prose
piece. The twelve etchings by Dine were printed on
paper specially hand made at the Richard-de-Bas paper
mill in Ambert, France. Each set of prints, together with
the text is encased in a cloth covered box.

BIOGRAPHY

1935 Born in Cincinnati, Ohio
1953- Studied at University of Cincinnati and Boston
 Museum School
1957 B.F.A., Ohio University
1958 Enrolled in graduate study at Ohio University
 Moved to New York
1967 Moved to London
1970 Moved to Putney, Vermont, where he presently resides.

ACADEMIC AFFILIATIONS

1965 Guest Lecturer, Yale University
 Artist in Residence, Oberlin College, Ohio
1967 Visiting Critic, College of Architecture, Cornell
 University, Ithaca, New York
1973 Visiting Artist, Graphicstudio, University of South
 Florida, Tampa, Florida
1975 Visiting Printmaker, Dartmouth College, Hanover,
 New Hampshire
1976 Artist-in-Residence, Williams College,
 Williamstown, Massachusetts

ONE-MAN EXHIBITIONS

1960 Reuben Gallery, New York
1962 Galleria dell'Ariete, Milan
 Martha Jackson Gallery, New York
1963 Galerie Zwirner, Cologne
 Galerie Ileana Sonnabend, Paris
 Palais des Beaux-Arts, Brussels
 Sidney Janis Gallery, New York
1964 Sidney Janis Gallery, New York
1965 Galleria Gian Enzo Sperone, Turin
 Allen Memorial Art Museum, Oberlin College,
 Oberlin, Ohio
 Robert Fraser Gallery, London
1966 Robert Fraser Gallery, London
1967 Galerie Ricke, Kassel
 Galerie Zwirner, Cologne
 The Gallery Upstairs, Buffalo
 Harcus/Krakow Gallery, Boston
 The Museum of Modern Art, New York
 Sidney Janis Gallery, New York
 Stedelijk Museum, Amsterdam
 Andrew Dickson White Museum of Art, Cornell
 University, Ithaca, New York
1969 Galerie Ileana Sonnabend, Paris
 Kunstverein, Munich
 Kunsthalle, Nuremberg
 Robert Fraser Gallery, London
1970 Dunkelman Gallery, Toronto
 Galerie Mikro, Berlin
 Galerie van de Loo, Munich
 Kestner Gesellschaft, Hanover
 Museo Civico Galleria d'Moderna, Turin

 Neue Galerie der Stadt Linz, Wolgang Gurlitt
 Museum, Linz
 Palais des Beaux-Arts, Brussels
 Sonnabend Gallery, New York
 Whitney Museum of American Art, New York
1971 Contract Graphics, Houston
 DM Gallery, London
 Galerie Ileana Sonnabend, Paris
 Kunsthalle, Bern
 Museum Boymans van Beuningen, Rotterdam
 Sonnabend Gallery, New York
 Staatliche Kunsthalle, Baden-Baden
 Staatliche Museum, Nationalgalerie, Berlin
 Städtische Kunsthalle, Düsseldorf
 Galerie der Spiegel, Cologne
1972 Aronson Gallery, Atlanta
 Galerie Gimpel & Hanover, Zurich
 Galerie Ileana Sonnabend, Paris
 John Berggruen Gallery, Newport Beach, California
1973 DM Gallery, London
 Felicity Samuel Gallery, London
 Galerie Gérald Cramer, Geneva
 Gimpel Fils, London
 Sonnabend Gallery, New York
1974 Galerie Ileana Sonnabend, Geneva
 Hopkins Center Art Galleries, Dartmouth College,
 Hanover, New Hampshire
 Institute of Contemporary Art, London
 Knoedler Prints Gallery, New York
 La Jolla Museum of Contemporary Art (The
 Summers Collection), La Jolla, California
 Sonnabend Gallery, New York
1975 Centre Culturel Américain, Paris
 Centre d'Arts Plastiques Contemporains, Bordeaux
1976 Williams College Museum of Art, Williamstown,
 Massachusetts
 Hayden Gallery, Massachusetts Institute of Technology,
 Cambridge, Massachusetts
1977 The Johnson Gallery of Middlebury College,
 Middlebury, Vermont
 University Art Gallery, State University of
 New York at Albany
 Herbert F. Johnson Museum of Art, Cornell University,
 Ithaca, New York
 The Pace Gallery, New York

GROUP EXHIBITIONS

1958 Judson Gallery, New York
1959 Judson Gallery, New York
 Reuben Gallery, New York
1960 Judson Gallery, New York: *The House* (Dine) and
 The Street (Oldenburg)
 Martha Jackson Gallery, New York: *New Forms—
 New Media I*
 Martha Jackson Gallery, New York: *New Forms—
 New Media II*
 Reuben Gallery, New York
 Andrew Dickson White Museum of Art, Cornell
 University, Ithaca: *Young Americans*

1961 Judson Gallery, New York: *Rainbow Thoughts*
Martha Jackson Gallery, New York: *Environments, Situations and Spaces*
United States Information Service Gallery, London: *Modern American Painting*
1962 Dallas Center for Contemporary Art: *1961*
National Museum of Modern Art, Tokyo: *Third International Biennial Exhibition of Prints*
Pace Gallery, Boston: *Pop Art*
Pasadena Museum: *New Paintings of Common Objects*
Sidney Janis Gallery, New York: *The New Realists*
1963 Galleria dell'Ariete, Milan: *Contemporary Americans*
The Solomon R. Guggenheim Museum, New York: *Six Painters and the Object*
Jerrold Morris International Gallery, Toronto: *Pop Art*
William Rockhill Nelson Gallery of Art, Kansas City: *Mixed Media and Pop Art*
Thibaud Gallery, New York: *According to the Letter*
Washington Gallery of Modern Art, Washington, D.C.: *The Popular Image*
1964 Art Institute of Chicago: *67th Annual American Exhibition*
The Solomon R. Guggenheim Museum, New York: *American Drawings*
Galerie Ileana Sonnabend, Paris: *New Drawings*
Moderna Museet, Stockholm: *New Realism and Pop Art*
Akademie der Kunste, Berlin
Gemeentemuseum, Hague
Museum des 20. Jahrhunderts, Vienna: *Pop, Etc.*
Poses Institute, Brandeis University, Waltham, Massachusetts: *New Directions in American Painting*
Rose Art Museum, Brandeis University, Waltham, Massachusetts: *Recent American Drawings*
Sidney Janis Gallery, New York: *Three Generations*
Stedelijk Museum, Amsterdam: *American Pop Art*
Tate Gallery (Gulbenkian Foundation), London: *Painting and Sculpture of a Decade*
XXXII International Biennial Exhibition, Venice
1965 Milwaukee Art Center: *Pop Art and the American Tradition*
Whitney Museum of American Art, New York: *A Decade of American Drawings*
Whitney Museum of American Art, New York: *Young America*
Worcester Museum of Art: *New American Realism*
1966 Loeb Center, New York University, New York: *Contemporary Drawings*
Sidney Janis Gallery, New York: *Erotic Art '66*
Whitney Museum of American Art, New York: *Art of the United States: 1670-1966*
1967 Corcoran Gallery of Art, Washington, D.C.: *30th Annual Exhibition of Contemporary Painting*
Expo '67, Montreal: United States Pavilion
Galleria del Leone, Venice: *Twelve Super-Realists*
Honolulu Academy of Arts: *Signals of the Sixties*
Kassel, Germany: *Documenta IV*
Stadt Darmstadt, Germany: *International der Zecchur*

1968 Art Institute of Chicago: *28th Annual Exhibition of the Society of Contemporary Art*
University of California, Riverside: *Recent Directions in American Art*
1969 Art Gallery of Ateneum, Helsinki
Hayward Gallery, London
Graham Gallery, New York: *The Big Drawing*
Museum of Modern Art of Tempere, Finland
1971 Akron Art Institute, Akron, Ohio: *Celebrate Ohio*
Cincinnati Art Museum, Cincinnati, Ohio: *From Hiram Powers to Laser Light*
Louisiana, Denmark: *American Art: 1950-1970*
Philadelphia Museum of Art, Philadelphia: *Multiples. The First Decade*
1972 Spoleto, Italy: *420 West Broadway at the Spoleto Festival*
1973 Cincinnati Museum of Art, Cincinnati, Ohio: *Dine-Kitaj*
Festival d'Automne, Paris
Museum of Modern Art, New York: *Modern Art in Prints*
Parcheggio di Villa Borghese, Rome: *Contemporanea*
Whitney Museum of American Art, New York
1974 Allan Frumkin Gallery, New York: *1961*
Carnegie Institute, Pittsburgh: *International Exhibition, 1964, 1967, 1969*
Dallas Museum of Fine Arts, Dallas: *Poets of the Cities: New York and San Francisco, 1950-1965*
DM Gallery, London
Margo Leavin Gallery, Los Angeles
Whitney Museum of American Art, New York: *American Pop Art*
Whitney Museum of American Art, New York: *Annual Exhibition, 1966, 1967, 1969, 1973*
1975 Moore College of Art, Philadelphia

HAPPENINGS

1959 *The Smiling Workman.* Judson Gallery, New York.
1960 *Car Crash.* Reuben Gallery, New York.
Jim Dine's Vaudeville. Reuben Gallery, New York.
The Shining Bed. Reuben Gallery, New York.
1965 *Natural History (The Dreams).* First New York Theatre Rally.

SELECT BIBLIOGRAPHY

STATEMENTS BY THE ARTIST

Dine, Jim. "All Right Jim Dine, Talk!" an interview with John Gruen, *World Journal Tribune*, 20 November 1966, p. 34.

_____. *American Drawings*. Catalogue of the exhibition at the Solomon R. Guggenheim Museum. (introduction by Lawrence Alloway) New York, 1964.

_____. *Another Look at Pop Art*. An unpublished tape recorded interview with Bruce Glaser for Radio Station WBAI (New York) 19 April 1965 at 9 P.M. Those interviewed were Jim Dine, James Rosenquist, and Robert Indiana. The tape is in the possession of the interviewer.

_____. *Art Now* vol. 2, no. 3 (1970) New York: University Galleries.

_____. "Dining with Jim." An interview with Robert Fraser. *Art and Artists* vol. 1 (September 1966) pp. 48-53.

_____. "Jim Dine au coeur de sa peinture," by Jaques Michel, *Le Monde* (Paris) 9 December 1970, p. 17.

_____. "Jim Dine's Red Mural for the U.S. Pavilion," by William C. Lipke. *Artscanada* vol. 24. (October 1967) Supplement p. 10.

_____. "Lithographs and Original Prints: Two Artists Discuss their Recent Work." *Studio International* vol. 175 (June 1968) Supplement p. 337.

_____. "Test in Art." Prepared by Kenneth Koch and taken by Jim Dine. *Art News* vol. 65 (October 1966) pp. 54-57.

_____. "The Toronto Symposium: Perishability, Pop Art and the Happenings: a New Look." Organized and moderated by Brydon Smith for the opening of the *Dine, Oldenburg, Segal* exhibition at the Art Gallery of Toronto. January 1967.

_____. "What is Pop Art." Part I by Georges R. Swenson. *Art News* vol. 62 (November 1963) pp. 25, 61-62.

_____. *Young America 1965*. Catalogue of the exhibition at the Whitney Museum of American Art. New York, 1965.

ARTICLES AND REVIEWS

Alloway, Lawrence. "Apropos of Jim Dine." *Oberlin College, Allen Memorial Art Museum Bulletin* vol. 23 (Fall 1965) pp. 21-24.

Ashton, Dore. "Commentary from New York and Washington." *Studio International* vol. 171 (February 1966) pp. 78-81.

Barrett, Cyril. "Jim Dine's London." *Studio International* vol. 172 (September 1966) pp. 122-123.

Battcock, Gregory. "Jim Dine," *57th Street Review* (New York) 15 November 1966, pp. 4-5.

Butterfield, J. "Contract Graphies, Houston." *Arts Magazine* vol. 45 (Summer 1971) p. 46.

Calas, Nicolas. "Jim Dine: Tools and Myth." *Metro* no. 7 (1967) pp. 76-79.

Coleman, Victor. "Look at My Product; Notes, More or Less Specific on Jim Dine." *Artscanada* vol. 27 (December 1970) pp. 50-51.

"Contemporary Graphics from the Museum's Collection." *Rhode Island School of Design Bulletin* vol. 59 (April 1973).

Davis, Douglas. "Personal Pop." *Newsweek*, 9 March 1970, pp. 98-99.

Denvir, Bernard. "DM Gallery Exhibit." *Art International* vol. 15 (May 1971) p. 76.

Dienst, Rolf-Günter. "Die Ironisierung des Gegenstandes—zu den Arbeiten von Jim Dine." *Das Kunstwerk* vol. 21 (1967-1968) pp. 11-12.

_____. "Jim Dine." *Das Kunstwerk* vol. 24 (May 1971) p. 49.

Dypreau, Jean. "Métamorphoses de L'École de New York." *Quadrum* no. 18 (1965) pp. 161-164.

Gablik, Suzi. "Reviews and Previews." *Art News* vol. 63 (November 1964) p. 12.

Glazebrock, Liz. "Jim Dine." *Album* vol. 1 (February 1970) pp. 42-43.

Goldman, Judith. "Exploring the Possibilities of the Print Medium." *Art News* (September 1973) pp. 35-36.

Gray, Cleve. "Print Review: Tatyana Grosman's Workshop." *Art in America* vol. 53 (December 1965-January 1966) pp. 83-85.

Henry, Gerrit. "New York Letter." *Art International* vol. 15 (June 1971) pp. 80-81.

Hess, Thomas. "Collage as an Historical Method." *Art News* vol. 60 (November 1961) pp. 30-33, 69-71.

Herrera, Hayden. "Jim Dine." *Art News* vol. 74 (February 1975) p. 83.

Irwin, David. "Pop Art and Surrealism." *Studio International* vol. 171 (May 1966) pp. 187-191.

Johnson, Ellen H. "Jim Dine and Jasper Johns." *Art and Literature* Paris (Autumn 1965) pp. 128-140.

J[ohnston], J[ill]. "Reviews and Previews." *Art News* vol. 60 (January 1962) pp. 12-13.

Jouffroy, Alain. "Jim Dine through the Telescope." *Metro* no. 7 (1962) pp. 72-75.

Kainen, Jacob. "Quality in Edition Prints." *Art News* vol. 93 (March 1974) p. 35.

Kaprow, Allan. "Happenings in the New York Scene." *Art News* vol. 60 (May 1961) pp. 36-39, 58-62.

Kelder, Diane. "Collaborative Experiments." *Art News* vol. 73 (March 1974) p. 80.

Kent, Sarah. "UK Reviews." *Studio International* vol. 188 (December 1974) pp. 6-7.

Kozloff, Max. "Art and the New York Avant-Garde." *Partisan Review* vol. 31 (Fall 1964) pp. 535-554.

_____. "The Honest Elusiveness of James Dine." *Artforum* vol. 3 (December 1964) pp. 36-40.

_____. " 'Pop' Culture, Metaphysical Disgust, and the New Vulgarians." *Art International* vol. 6 (March 1962) pp. 34-36.

Kramer, Hilton. "The Thingification of Sculpture," *New York Times*, 13 November 1966, p. D17.

Lipke, William C. "Perspectives of American Sculpture, Part I: Nancy and I at Ithaca, Jim Dine's Cornell Project." *Studio International* vol. 174 (October 1967) pp. 142-145.

Loring, John. "Graphic Arts: Hairy, Alive, Purple, Sexy, Rich." *Arts Magazine* vol. 48 (January 1974) pp. 52-53.

Lucie-Smith, Edward. "Flamboyance and Eclecticism: London Commentary." *Studio International* vol. 171 (June 1966) pp. 265-267.

Mandelbaum, Ellen. "Isolable Units, Unity, and Difficulty." *Art Journal* vol. 27 (Spring 1968) pp. 256-261.

Melville, Robert. "The Victimized Figure." *The Architectural Review* vol. 140 (September 1965) pp. 201-203.

Montgomery, Cara. "Jim Dine at Gimpel Fils, London." *Studio International* vol. 186 (December 1973) pp. 248-249.

Novick, Elisabeth. "Happenings in New York." *Studio International* vol. 172 (September 1966) pp. 154-159.

Perrone, John. " 'Poets of the Cities.' San Francisco Museum of Art." *Artforum* vol. 13 (May 1975) p. 82.

P[etersen], V[alerie]. "Reviews and Previews." *Art News* vol. 59 (December 1960) pp. 16-17.

"Prints and Portfolios Published." *Print Collector's Newsletter* vol. II, no. 1 (March-April 1971) p. 14.

_____. *Print Collector's Newsletter* vol. V, no. 5 (November-December 1974) p. 116.

_____. *Print Collector's Newsletter* vol. VI, no. 3 (July-August 1975) p. 72.

_____. *Print Collector's Newsletter* vol. VI, no. 5 (November-December 1975) p. 134.

_____. *Print Collector's Newsletter* vol. VII, no. 1 (March-April 1976) p. 23.

_____. *Print Collector's Newsletter* vol VII, no. 4 (September-October 1976) pp. 116-117.

Restany, Pierre. "Le Nouveau Realisme a la Conquête de New York." *Art International* vol. 7 (January 1963) pp. 29-36.

Robinson, Frank and Shapiro, Michael. "Jim Dine at 40." *Print Collector's Newsletter* vol. VII, no. 4 (September-October 1976) pp. 101-105.

Rose, Barbara. "Dada Then and Now." *Art International* vol. 7 (January 1963) pp. 22-28.

Rosenberg, Harold. "The Art Galleries." *The New Yorker*, 24 November 1962, pp. 161-162, 165-167.

Russell, John. "London." *Art News* vol. 65 (November 1966) pp. 58, 87.

_____. "Pop Reappraised." *Art in America* vol. 57 (July-August 1969) pp. 78-89.

_____. "Jim Dine and the Idea of the Print." *London Magazine* vol. 10 (May 1970) pp. 48-55.

Saff, Donald J. "Graphicstudio, U.S.F." *Art Journal* vol. XXXIV, no. 1 (Fall 1974) pp. 10-18.

Schjeldahl, Peter. "Artists in Love with their Art," *New York Times*, 3 November 1974, pp. D30-33.

Smith, Brydon. "Jim Dine—Magic and Reality." *Canadian Art* vol. 23 (January 1966) pp. 30-34.

Solomon, Alan R. "Jim Dine and the Psychology of the New Art." *Art International* vol. 8 (October 1964) pp. 52-56.

Stein, Donna M. [Suite of six portrait etchings which narrate the life of Arthur Rimbaud]. *Art News* vol. 73 (April 1970) p. 60.

Swenson, Georges R. "The New American Sign Painters." *Art News* vol. 61 (September 1962) pp. 44-47, 60-62.

Tillim, Sidney. "Month in Review." *Arts Magazine* vol. 37 (March 1963) pp. 59-62.

Tomkins, Calvin. "Profiles." *The New Yorker*, 7 June 1976, pp. 42-76.

Towle, Tony. "Notes on Jim Dine's Lithographs." *Studio International* vol. 179 (April 1970) pp. 165-168.

Vincklers, Bitite. "New York: Jim Dine, Keith Sonnier." *Art International* vol. 14 (May 1970) pp. 82-83.

Wedewer, Rolf, as translated by Michael Werner. "Environments and Rooms." *Art and Artists* vol. 5 (July 1970) pp. 16-18.

Willard, Charlotte, "Drawing Today." *Art in America* vol. 52 (October 1964) pp. 49-67.

Zack, David. "A Black Comedy . . ." *Artforum* vol. 4 (May 1966) pp. 32-34.

CATALOGUES

Amsterdam, Stedelijk Museum. *American Pop Art.* (essay by Alan R. Solomon) 1964.

_____ Stedelijk Museum, *Jim Dine; Tekeningen.* ("Dine Drawings," by Alan R. Solomon) 1966.

Berlin, Akademie der Kunste. *Neue Realisten und Pop Art.* (essay by Werner Hofmann) 1964.

_____ Galerie Mikro. *Jim Dine; Complete Graphics.* (essays by John Russell, Tony Towle, and Wieland Schmied) 1970.

Bordeaux, Centre d'Arts Plastiques Contemporains de Bordeaux. *Jim Dine.* 1975.

Buffalo, The Buffalo Fine Arts Academy, Albright-Knox Art Gallery. *Mixed Media and Pop Art.* (foreword by Gordon M. Smith) 1963.

Cincinnati, Cincinnati Art Museum. *Dine-Kitaj.* (essays by R.J. Boyle and R.B. Kitaj) 1963.

Cologne, Wallraf-Richartz Museum. *Kunst der sechziger Jahre.* (texts by Peter Ludwig, Horst Keller, and Evelyn Weiss) 1969.

Hanover, Germany, Kestner Gesellschaft. *Jim Dine.* (essay by Wieland Schmied) 1970.

Irvine, University of California at Irvine Art Gallery. *New York: The Second Breakthrough, 1959-1964.* (preface and essay by Alan R. Solomon) 1969.

Kansas City, Nelson Gallery, Atkins Museum. *Popular Art.* (text by Ralph Coe) 1963.

London, Robert Fraser Gallery. *Jim Dine.* (article by Cyril Barrett) 1966.

_____ Gimpel Fils Gallery. *Jim Dine: Seven New Paintings.* 1973.

Milwaukee, Milwaukee Art Center. *Pop Art and the American Tradition.* (text by Tracy Atkinson) 1965.

Munich, Kunstverein. *Jim Dine.* 1969.

New York, The Solomon R. Guggenheim Museum. *Six Painters and the Object.* (essay by Lawrence Alloway) 1963.

_____ The Solomon R. Guggenheim Museum. *Eleven From the Reuben Gallery.* (introduction by Lawrence Alloway) 1965.

_____ Martha Jackson Gallery. *New Forms—New Media I.* (essay by Lawrence Alloway and Allan Kaprow) 1960.

_____ Martha Jackson Gallery. *New Forms—New Media II.* 1960.

_____ Sidney Janis Gallery. *Jim Dine.* ("Someone Says: It Really Looks Like It," by Oyvind Fahlstrom) 1963.

_____ Sidney Janis Gallery. *New Realists.* (preface by John Ashbery, excerpts from "A Metamorphosis in Nature,"

by Pierre Restany, and essay by Sidney Janis) 1962.
——— Sidney Janis Gallery. *Seven Artists.* 1969.
——— Sidney Janis Gallery. *Erotic Art.* (introduction by Sidney Janis) 1966.
——— The Jewish Theological Seminary of America, the Jewish Museum. *Black and White.* (introduction by Ben Heller and statement by Robert Motherwell) 1963.
——— The Metropolitan Museum of Art. *Prints by Five New Artists.* 1969.
——— The Museum of Modern Art. *The Art of Assemblage.* (text by William Seitz) 1961.
——— The Museum of Modern Art. *Jim Dine: Designs for A Midsummer Night's Dream.* (introduction by Virginia Allen) 1968.
——— Whitney Museum of American Art. *1965 Annual Exhibition of Contemporary American Painting.* 1965.
——— Whitney Museum of American Art. *Annual Exhibition 1966: Sculpture and Prints.* 1966.
——— Whitney Museum of American Art. *1967 Exhibition of Contemporary American Painting.* 1967.
——— Whitney Museum of American Art. *Jim Dine.* (essay by John Gordon) 1970.
——— Whitney Museum of American Art. *1973 Biennial Exhibition: Contemporary American Art.* 1973.
Nuremberg, Kunsthalle Nürnberg am Marientor. *Jim Dine.* 1969.
Paris, Galerie Ileana Sonnabend. *Jim Dine.* (texts by Alain Jouffroy, Gillo Dorflies, Lawrence Alloway, and Nicolas Calas) 1963.
Philadelphia, Philadelphia Museum of Art. *Multiples. The First Decade.* (text by John L. Tancock) 1971.
Pittsburgh, Museum of Art, Carnegie Institute. *The 1964 Pittsburgh International Exhibition of Contemporary Painting and Sculpture.* 1964.
——— Museum of Art, Carnegie Institute. *The 1967 Pittsburgh International Exhibition of Contemporary Painting and Sculpture.* 1967.
Rome, Villa Borghese. *Contemporanea.* (text by Achille Bonito Oliva) 1974.
Rotterdam, Museum Boymans van Beuningen. *Jim Dine; Schilderijen, Aquarellen, Objecten en het Complet Graphische Oeuvre.* 1971.
Stockholm, Moderna Museet. *Amerikanste Pop-Kunst.* (texts by Alan R. Solomon and Billy Klurer) 1964.
Toronto, Art Gallery of Ontario. *Dine, Oldenburg, Segal.* (preface by Brydon Smith and essay "Jim Dine: Hot Artist in a Cool Time," by Alan R. Solomon) 1967.
Venice, Biennale International d'Arts. *Catalogo della XXXII Esposizione.* (introduction to "Stati Uniti d'America," by Alan R. Solomon) 1964.
Waltham, Massachusetts, Brandeis University, The Poses Institute of Fine Arts, The Rose Art Museum. *New Directions in American Painting.* (introduction by Sam Hunter) 1963.
——— Brandeis University, The Poses Institute of Fine Arts, The Rose Art Museum. *Recent American Drawings.* (introduction by Thomas H. Garver) 1964.
Washington, D.C., Gallery of Modern Art. *The Popular Image Exhibition.* ("The New Art," by Alan R. Solomon) 1963.
Worcester, Massachusetts, Worcester Art Museum. *The New American Realism.* (prefatory note by Danial Catton Rich and introduction by Martin Carey) 1965.

BOOKS

Alloway, Lawrence. *Topics in American Art Since 1945.* New York: W.W. Norton, 1975.
Amaya, Mario. *Pop as Art; A Survey of the New Super-Realism.* London: Studio Vista, 1965.
———. "American Pop Art" in *Art Since Mid-Century; the New Internationalism.* With contributions by Werner Haftmann and others. Foreword by Jean Leymarie. 2 vols., vol. 2 *Figurative Art.* Greenwich, Conn.: New York Graphic Society, 1971.
Calas, Nicholas. *Art in the Age of Risk.* New York: E.P. Dutton & Co., 1968.
——— and Calas, Elaine. *Icons and Images of the Sixties.* New York: E.P. Dutton & Co., 1971.
Compton, Michael. *Pop Art: Movements of Modern Art.* London: Hamlyn Publishing Group, 1970.
Dienst, Rolf-Günter. *Pop-art: Eine kritische Information.* Wiesbaden: Limes Verlag, 1965.
Finch, Christopher. *Pop Art: The Object and the Image.* Edited by David Herbert. London: Studio Vista, 1968.
Hansen, Al. *A Primer of Happenings and Time-Space Art.* New York and Paris: Something Else Press, 1965.
Hunter, Sam. *American Art of the Twentieth Century.* New York: Harry N. Abrams, 1973.
Kaprow, Allan. *Assemblage, Environments and Happenings.* New York: Harry N. Abrams, 1966.
Kozloff, Max. *Renderings, Critical Essays on a Century of Modern Art.* New York: Simon and Schuster, 1968.
Lippard, Lucy R. *Pop Art.* New York: Frederick A. Praeger, 1966.
Pluchart, François. *Pop Art et Cie.* Paris: Martin Malburet, 1971.
Rublowsky, John. *Pop Art.* New York: Basic Books, 1965.
Russell, John and Gablik, Suzi. *Pop Art Redefined.* London: Thames and Hudson, 1969.
Seitz, William. *The Art of Assemblage.* Garden City, New York: Doubleday & Co., 1961.

FILMS ON DINE

1965 *Jim Dine.* 16 mm sound. Produced by National Educational Television, directed by Lane Slate. *Métamorphoses.* Produced by Télévision Belge, a documentary series directed by Jean Antoine. Interviews with Dine, Lichtenstein, Marisol, Segal, Warhol, and Bontecou. Conversation reprinted in *Quadrum,* no. 18 (1966) pp. 161-164.
1971 *Jim Dine, London.* 16mm, color, 28 minutes. Produced by Blackwood Productions, Inc.

TEXTS CREATED OR ILLUSTRATED BY DINE

1967 *Nancy and I at Ithaca.* Ithaca, New York: Andrew Dickson White Museum of Art, Cornell University. Design and collage by Jim Dine with notes by William C. Lipke and photographs by William C. Lipke and John White.

1968 *The Poet Assassinated.* New York and San Francisco. Holt, Rinehart, and Winston. Poetry by Guillaume Appollinaire as translated by Ron Padgett with illustrations by Jim Dine.

 The Picture of Dorian Gray. London: Petersburg Press. A working script for the stage from Oscar Wilde's novel with original images and notes on the text by Jim Dine. The book was published in three editions: A, an edition of two hundred with six signed, loose lithographs, is bound in red velvet; B, an edition of two hundred with four signed, loose etchings, is bound in green velvet; and C, an edition of one hundred with six signed, loose lithographs and four signed, loose etchings, is bound in red leather.

1969 *Welcome Home Lovebirds.* London: Trigram Press. Poetry and drawings by Jim Dine.

 Photographs and Etchings. London: Petersburg Press. An edition of seventy-five with fifteen artists' proofs, sixteen loose images of photographs and etchings on paper. Photographs by Lee Friedlander, etchings by Jim Dine. Each image is numbered and signed by the artists.

 Work From the Same House. London: Trigram Press. A paperback edition of *Photographs and Etchings.*

1970 *The Adventures of Mr. and Mrs. Jim and Ron.* London: Cape Goliard Press. A collaborative work by Jim Dine and Ron Padgett.

1977 *Mabel.* Paris: Aldo Crommelynck. Prose piece by Robert Creeley and twelve etchings by Jim Dine. An edition of sixty with ten artist's proofs, each set of prints encased in a cloth covered box.

JIM DINE

PRINTS:
1970-1977

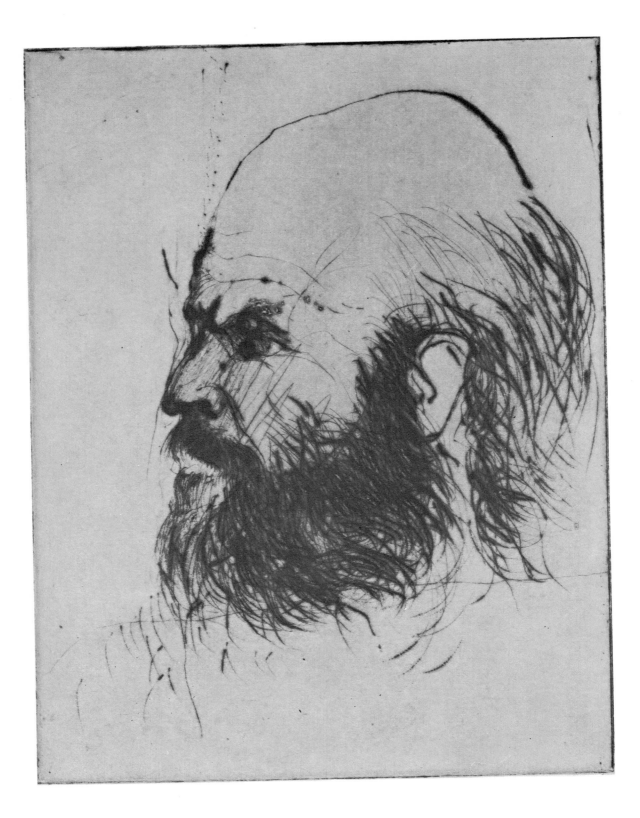